The Complete
CARTOONING
Course

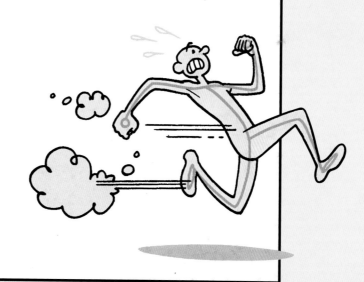

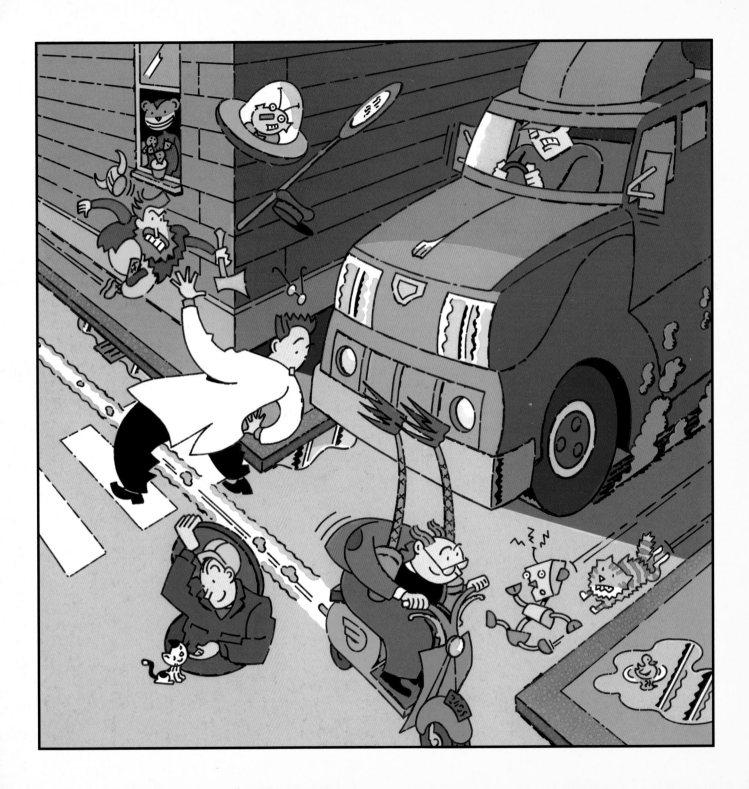

The Complete CARTOONING Course

Principles, Practices, Techniques

by Steve Edgell
with Brad! Brooks and Tim Pilcher

BARRON'S

Foreword

There are typical reactions from people when you tell them that you draw cartoons or that you work in comics—their faces tend to subtly alter: their brow seems a little less furrowed, their eyes widen, the corners of their mouth turn up, and they may, occasionally, break into a smile. It's as though an invisible burden has been lifted and the hitherto potentially arduous task of talking to you has been transformed into a fun, friendly, easy-going conversational experience. The stage may even now be set for a gushing revelation about how they have always enjoyed cartoons themselves and how they always remember one particular popular cartoon character or regular newspaper feature that has provided them with entertainment since they were knee high to a magazine rack.

If only everything were as simple as cartoons.

Such people are the audience for cartoons, the readers, and they populate the whole social spectrum. From patient, middle-aged mothers to teenage skate-punks, readers come to cartoons in the expectation that they're entering a world free of communicative pomp or difficulty, and full of visual straight-talking. Put another way, cartoons are a kind of "demotic vernacular language," as a museum curator from Long Island, New York, cheerfully and ironically informed me some years ago when she organized an exhibition placing comic strips and cartoons alongside sequential picture works and political photomontages. She added that you only had to look at the cartoons spray-painted in public places by graffiti

Cartoons cross all social divides... class, age, race, and culture.

artists to see that they were, literally, the graphic writing on the wall. I thought of what she had said when, in Santander, northern Spain, I read the three huge public information boards by the marina which explained the whole harborside development in cartoon form; and again on the Mexico City metro when I saw, pasted over one of the carriage doors, a photocopied satirical caricature that showed to the traveling public what its creator thought the president was doing to the constitution; and yet again when someone brought me a children's toy back from Tokyo which had a set of cartoons on its packaging as the directions for use.

Everything you read in this book is designed to teach you how to be a part of this popular communicative world of cartooning. Whether you're into drawing a comic strip or a GIF animation, or if you just like the idea of being able to hold a piece of paper in front of somebody's face and make them laugh, *The Complete Cartooning Course* provides you with the opportunity to learn the tools of the trade and to get to grips with this all-encompassing art form.

A QUARTO BOOK

First published in the United States and Canada in 2001 by Barron's Educational Series, Inc.

Copyright © 2001 Quarto Inc.

All inquiries should be addressed to:
Barron's Educational Series, Inc.
250 Wireless Boulevard
Hauppauge, New York 11788
http://www.barronseduc.com

Library of Congress Catalog Card No.: 99-35139

International Standard Book No.: 0-7641-1318-6

QUAR.RAC

Conceived, designed, and produced by
Quarto Publishing plc
The Old Brewery
6 Blundell Street
London N7 9BH

Editor **Kate Michell**
Senior Art Editor **Penny Cobb**
Text editors **Claire Waite, Ian Kearey**
Designer **Karin Skånberg**
Photographers **Paul Forrester, Martin Norris**
Indexer **Dorothy Frame**

Art Director **Moira Clinch**
Publisher **Piers Spence**

Manufactured by Universal Graphics Pte Ltd, Singapore
Printed by Star Standard Industries (Pte) Ltd, Singapore

Contents

Introduction

The word cartoon means many different things to different people, and rightly so. From greeting cards to fine art and design, there is an almost unparalleled usage of cartoons in every aspect of modern life. Having reached just about every corner of society, it is one of the most popular forms of communication.

Cartooning is everywhere!

Unlike fine art, which bases itself on the uniqueness of one individual creation, modern cartooning is all about mass reproduction. Cartooning specializes in getting a message or an idea across to as many people as possible in the widest ways imaginable. What may start as a small original drawing may end up on hundreds of thousands of birthday cards or in millions of newspapers. Thus, what was a small concept that may have only been seen, in its original form, by a few dozen people, can now be reproduced so that entire nations can instantaneously be amused, informed, entertained, or made to think. This means that cartoons are a very powerful—and very underestimated—art form.

For the cartoonist this means an almost unlimited use of their skills in every medium. Look at any packaging, from chips to cola and ads on billboards or television, and you'll soon discover how ubiquitous the cartoon is—with good reason, too. The cartoon is the fastest, simplest, and

Cartooning can be used in many varied ways to **express a multitude of ideas...**

▼ **Cartoon strips**

Artists like Steve Bell, Bill Watterson, and Charles Schultz have been responsible for a resurgent interest in strip cartoons.

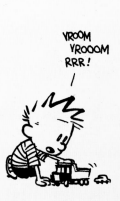
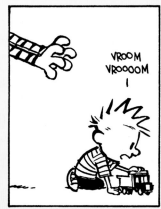

When starting to draw cartoons it is best to remember for what media the cartoon is intended and who **the intended audience is.** If you are drawing for a **newspaper** make it **topical,** or for an **ad** make sure it **answers the demands requested.**

most effective way of communicating an idea, joke, concept, or thought. It really is a case of a picture painting a thousand words!

A Cartoon for every Occasion

Daily newspapers regularly have large, half-page editorial cartoons satirizing politics and modern society—it may be one large picture communicating several ideas, or the same ideas broken down into a series of vignettes.

Another form of cartoons in newspapers includes smaller "gag" cartoons that accompany, and comment on, relevant stories, and often appear on the front page of national newspapers. Finally, there are "strip" cartoons, which use a series of drawings in sequence to tell an often humorous story. While the latter are mostly for entertainment, they are occasionally used for satirical purposes as well.

The cartoon also exists to purely entertain in many other mediums including animation, which is the idea

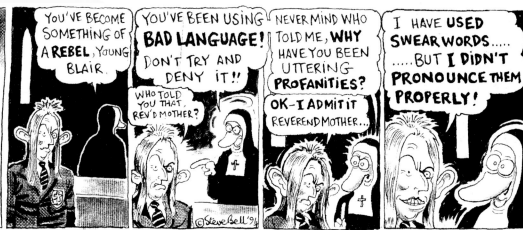

...and can even
transcend language barriers.

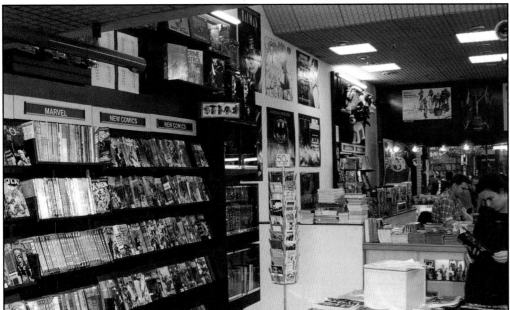

◄ **International history**

*Comics have been considered
an art form for many years,
and most cities have a
specialist shop or two.*

▼ **Take your pick**

*Cartoons come in many
shapes and sizes!*

come to life. This can be aimed at a wide audience, from
children's cartoons right up to more mature material that
can appeal to several age groups, such as *The Simpsons*.
The latter type of animated cartoon has seen a huge
increase in popularity over the last five to ten
years. Comics, too, are aimed at a wide
range of ages and, like the movies, can
cover a variety of genres, from westerns
and horror to superheroes and science
fiction. Using a similar technique to the
newspaper strip cartoons, comics tell a story
through a series of sequential drawings over
several pages. Today, many magazines run strip
cartoons or several pages of comics. Magazines
and newspapers also run cartoon illustrations
alongside articles, or as an opening page to a
story and even as front covers.

And of course there is advertising; whether an
illustration on a billboard or in a magazine, an
animated television advertisement, or even the
packaging itself, all can use cartoons effectively.

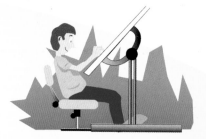

The most important thing to remember with cartooning is that, above all, it's fun!

There are so many choices it can seem a bit daunting to know where to start. This book will give you all the information you need to begin a career as a successful cartoonist in any field.

Cartooning is primarily a commercial art with the intention of making money as opposed to art for its own sake. Having said that, there are specialist art galleries and societies that do collect classic cartoons, and prices for early or rare drawings can get quite high, but these are only for published cartoons. You will make the most money when your solicited drawings are accepted or you are commissioned by an editor.

The Cartoon Medium

Cartoons are very different from regular illustrations or fine artwork in several key areas. So what exactly makes a cartoon "work"?

That which makes cartoons unique graphically is the key to understanding how they work. Whereas a traditional artist or illustrator may be interested in portraying a person or setting in either an approximation of reality or, conversely, an abstract representation, the cartoonist is more interested in getting the message across in the simplest terms.

Cartoons work on the principle of less is more.

Overuse of a technique such as cross-hatching, or a realistic portrait, only detracts from the core idea. The simpler the drawing, either in terms of figurework, rendering, etc., the clearer the message is. This is not to say that various techniques, such as the use of spot color or shading, can't be used to good effect as well, but it is important not to overpower the central theme.

The same rules could also be applied to the

conceptual side of cartooning—the purer the message, the better the communication. A gag cartoon with too many elements will be far less effective than one that has one simple, clever joke.

What cartoons do best is quick communication.

Taking the idea and conveying it clearly and concisely, whether it is a humorous one or a social commentary, and adding a strong graphic recognition that speaks directly to the reader is the strong point of the cartoon. The reason behind this is how the readers perceive the cartoon—the simpler a drawing, the easier it is for the readers to impose themselves into the visual, thus identifying with the situation more readily. This is known as amplification through simplification.

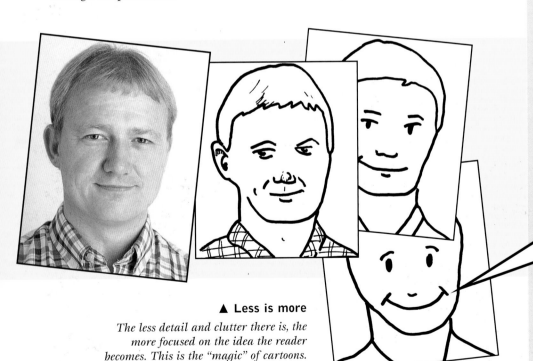

▲ **Less is more**
The less detail and clutter there is, the more focused on the idea the reader becomes. This is the "magic" of cartoons.

Over to you...

Take a look at a magazine or newspaper, or examine food packaging the next time you go shopping, and you will soon discover many types of cartoons being used in a whole variety of ways. If you come across an illustration that particularly appeals to you, make a note of it or keep a copy, and you will soon build up a substantial scrapbook of ideas and concepts. Throughout this course the scrapbook will be your most important tool after your drawing implements, as it will be the well from which you will draw inspiration.

So turn to the first chapter on getting set up, get your equipment together, and start a new career!

How to use this book

Using step-by-step exercises, annotated cartoons of every type—from caricature and advertising to comic strips and computer games—and instructional photographs on techniques, The Complete Cartooning Course *teaches cartoonists of all levels and genres everything they need to know about cartooning, and then encourages them to try these methods out themselves. By explaining how the instructional techniques work, this page will help guide you through the course.*

Hints, tips, suggestions, and further exercises for the reader to try are detailed, giving you direction and inspiration.

Practical step-by-step instructions on creating cartoon artwork are shown via photographs.

Step-by-step explanations on how to create cartoon artwork are given.

Other relevant sections of the book are cross-referenced.

We let you in on some tricks of the trade, giving you rare insight into the world of the cartoonist.

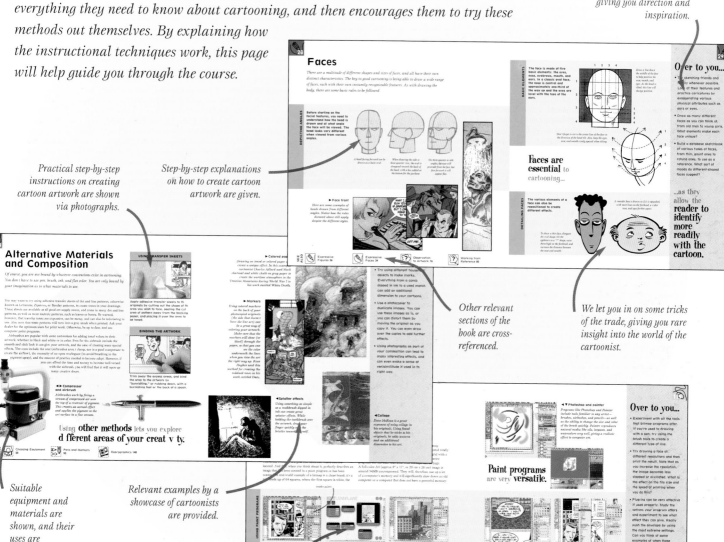

Suitable equipment and materials are shown, and their uses are explained.

Relevant examples by a showcase of cartoonists are provided.

In some cases, practical step-by-step instructions are illustrated using screen grabs.

Chapter 1
Getting to Work

Becoming a **cartoonist** is as easy as grabbing **a pen and some paper,** but finding the space to **create** and working with the **right equipment** will undoubtedly make the experience more **enjoyable and fulfilling.** **Comfort** is an important **consideration** when you're trying to be **creative.** If you're **serious** about being a **cartoonist,** then you'll find yourself spending **a lot of time** working at your **art,** so you should **make sure** you're at ease with both your **working environment** and

The right atmosphere can often be a source of inspiration in itself. You'll find yourself looking forward to working and eager to start.

with the **tools that you are using.** You will probably **find it** helpful to create some **space** that you can **call your own,** where you **won't** encounter many disruptions. Choosing the **right equipment** from the **outset** will also help smooth the path.

Having a particular space to create in is very important. Here we see a studio set up in a room specifically set aside for cartooning. There's ample space to create, the sofa allows for comfort when thinking, and the windows let in plenty of natural light.

The Workspace

As the name suggests, the workspace is the area in which you work. While this could be as large as a whole studio or as small as a dedicated area in a kitchen or bedroom, one thing remains constant: the need for a particular space you can call your own, where you can find everything you need to get down to the business of cartooning.

A workspace should provide an oasis where you can work without too many interruptions, and it should be as comfortable as possible to enable you to work effectively. Don't neglect this last point. If you intend to make cartooning your career, then expect to spend long days at the drawing table, sitting in one position for hours at a time. Backache can be a real problem if you are not adequately prepared.

When you first start out, you needn't spend lots of money getting the best equipment. However, if you're really serious about cartooning as a profession, then spending a little extra at the beginning will set you up properly. The general rule is to get the best you can afford.

Buying professional equipment like a freestanding drafting table, an expensive computer, or a flat file won't make you a better cartoonist, but it will help to instill the attitude you need in order to be a working cartoonist rather than just an amateur.

The specifications and equipment needed in your workspace will vary, but some or all of the following will be necessary.

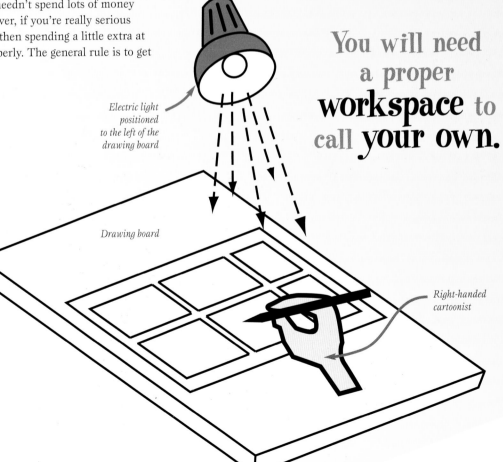

You will need a proper **workspace** to call **your own.**

Electric light positioned to the left of the drawing board

Drawing board

Right-handed cartoonist

▶ Lighting

It is vitally important that you have enough light to work by. Ideally this should be natural light, but a good source of electric light is a must as well. Remember to place your drawing surface at a right-angle to the source of the light on the opposite side to the hand that you draw with; for example, if you are right-handed, have the light coming from the left. This way you won't create art-obscuring shadows with your own hand. If you use a computer, it's a good idea to have the screen facing at a right-angle to the light source, too.

▼ What should I draw on?

A surface to draw on can be as simple as a lapboard propped up against a kitchen table, or you can choose a more permanent tilting drafting table. Whatever surface you use, it should be able to tilt, at least slightly, expecially if you work with large cartoons. Drawing on a flat surface can cause a distortion of perspective in your work. Additionally, the surface you use should be large enough to take comfortably the size of paper you draw on. There's nothing worse than trying to draw on a surface that's too small. Think about the edges of the surface, too. They should be as straight as possible in order for you to use a T-square to square off your drawings.

Office chair

◄ Seating

You are going to be sitting down for hours at a time, in the same or a similar position, so you owe it to yourself to get the most comfortable and ergonomically correct chair you can afford. This does not need to be the most expensive chair, but a decent office chair could save you the misery of a backache now and back problems in later life.

Wheeled system of drawers

Tilted drawing board

► Storage

You will also need a place to store your artwork and art equipment. For artwork, a flat file is ideal, if a little expensive; a system of shelves can do just as well. For equipment, a series of clean containers or jars will suffice, but if money is no object, then an art box is best. Consider also a taboret, a small wheeled system of drawers designed for artists. The taboret is handy in that it can be placed next to your drawing surface and hold ink, brushes, and other bits and pieces.

Container of equipment

Making Room

Once you have found somewhere to work, whether a whole room or studio or in an area of another room, how do you now make enough space to contain the paraphernalia you need to be a cartoonist?

Of course, the answer to the question above depends on how much space you have available. If you're lucky enough to have a studio, then you'll find it easier to set up your workspace than if you are working out of your bedroom. But there are a few rules of thumb that apply across the board.

Your workspace should be in an area where everything you need can be easily located and utilized. Even if you're not the tidiest of people, you should at least have your own system for finding the equipment and information that you need as quickly as possible. More time has been wasted by cartoonists hunting for a reference they know they have, somewhere, than by anything else.

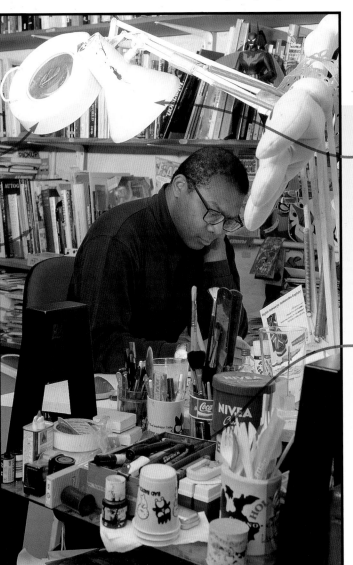

A magnifying glass might be useful for those tricky little details.

A system of shelves is useful for storing reference material such as books, magazines, and newspapers.

A good directional overhead light is a necessity in the workspace.

If you work on a slanted drawing board, set up a surface next to the board on the same side as your drawing hand on which you can place your inks, pens, and other assorted pieces of equipment.

Plan your workspace **carefully...**

◄Within reach

Have everything you need close to hand. The last thing you need when you're working is to have to scramble around looking for the right brush or a photo reference.

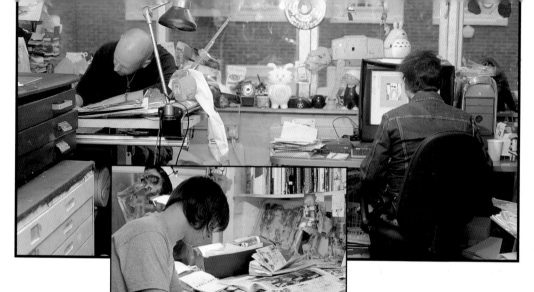

◄ Sharing workspace

If you are sharing a studio with others, then a little consideration for those around you is appropriate. Try not to spread out beyond your area, and ask before you borrow. Working with others in a studio can be very rewarding, as you get instant feedback and a sense of camaraderie, but it can be unpleasant if you're not careful and considerate.

...although you can always **change things around later**, giving enough **thought to the problem** at the **beginning** will always save time.

Cantilever action allows all trays to be visible and accessible at the same time.

An art box with partitioned trays is particularly useful for storing small items such as nibs and erasers.

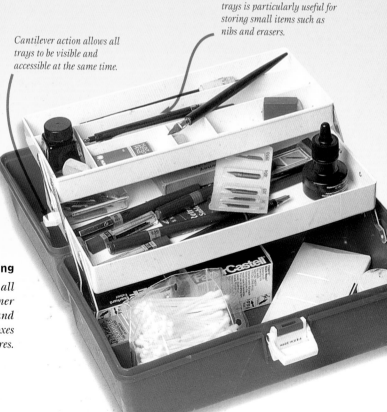

► Space-saving

If space is at a premium, consider keeping all of your equipment in a portable container such as an art box that can be moved around if need be. Less expensive substitutes for art boxes can be found in hardware and sporting stores.

Choosing Equipment

Equipment is a personal thing. Some people have tried to use traditional cartooning tools and found them wanting, while others swear by them. Finding the equipment that you're happiest using is a process of trial and error, and can be quite fun.

The basic equipment that cartoonists have used for years include pencils, erasers, pens (dip, fountain, stylograph, marker), brushes, India ink, Bristol board (a type of paper), rulers and other templates, dyes or paints for color work, and of course, a drawing board (whether it's a lapboard or a freestanding drafting table).

Although the numerous types of equipment that you can buy and use may seem bewildering to the beginner, when starting out you can get away with only the simplest tools. Choose and use the equipment you feel most comfortable with. Don't be swayed by what others tell you—your best work will come when you feel comfortable with your working experience.

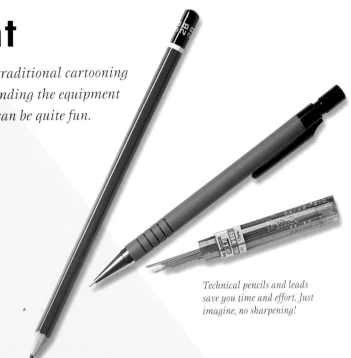

Technical pencils and leads save you time and effort. Just imagine, no sharpening!

Don't skimp on the quality of the equipment you choose...

A good cutting mat and a decent mat knife will make life a lot easier if you have to cut paper to size or prepare patches to correct artwork. Make sure you get a "self-healing" cutting mat, however, as other types will soon slice up and become next to useless. A good metal ruler will also be an invaluable tool when cutting.

Erasers are not just for rubbing out mistakes. A decent kneaded eraser like this one can also be used as a creative tool.

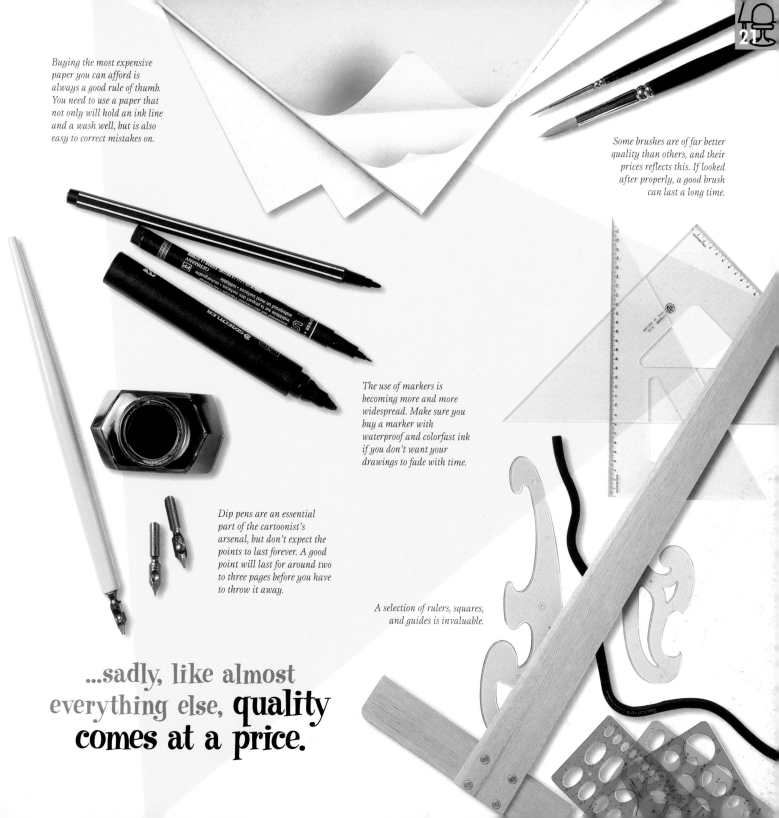

Buying the most expensive paper you can afford is always a good rule of thumb. You need to use a paper that not only will hold an ink line and a wash well, but is also easy to correct mistakes on.

Some brushes are of far better quality than others, and their prices reflects this. If looked after properly, a good brush can last a long time.

The use of markers is becoming more and more widespread. Make sure you buy a marker with waterproof and colorfast ink if you don't want your drawings to fade with time.

Dip pens are an essential part of the cartoonist's arsenal, but don't expect the points to last forever. A good point will last for around two to three pages before you have to throw it away.

A selection of rulers, squares, and guides is invaluable.

...sadly, like almost everything else, **quality comes at a price.**

Computer Cartooning

If, like so many cartoonists today, you're considering jumping into the digital world, then a decent and powerful computer is a must. Be warned, however, that going the digital route is somewhat expensive; buying a computer doesn't stop with purchasing the computer itself.

▼ PC or Mac?

Although a PC (personal computer) is perfectly adequate for most cartooning work (and probably slightly better for 3-D work), we would recommend getting an AppleMac for your digital cartooning work. Not only are Macs traditionally industry standard in the arts and publishing world, they're also a lot more intuitive to use.

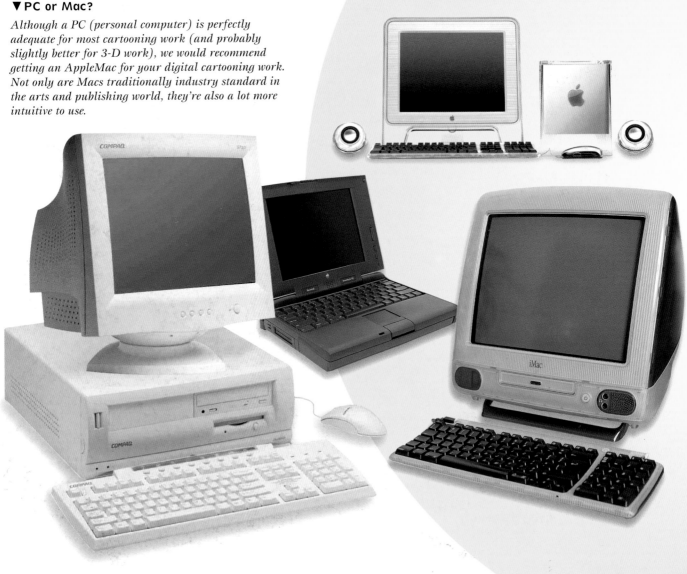

▼ What will I need?

The world of digital cartooning is discussed in detail in the Materials and Methods: Digital Media chapter (see pages 110-125). On this page you will find the accessories you will need if you decide to take this artistic route.

Buying cheaper equipment when you start out may seem like a **good idea, but** if you're really serious about cartooning as a career (or even a hobby), you may find that **it's a false economy.**

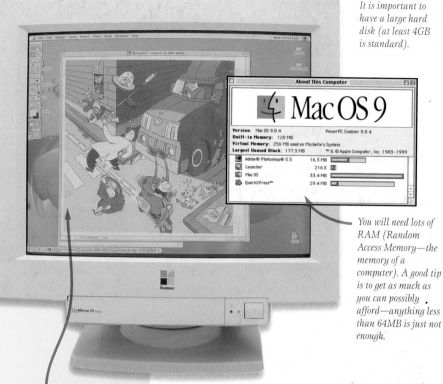

It is important to have a large hard disk (at least 4GB is standard).

You will need lots of RAM (Random Access Memory—the memory of a computer). A good tip is to get as much as you can possibly afford—anything less than 64MB is just not enough.

A good monitor with at least a 15 inch (38 cm) screen size will do, although a 21 inch (53 cm) screen is ideal.

A graphics tablet is also necessary—trying to draw with a mouse is like trying to paint with a bar of soap.

Although it can be costly, good software is a must.

A decent video card is necessary if you use a PC or if you're doing 3-D work on a Mac.

Chapter 2
Cartoon Drawing

Having **introduced** you to some of the **things you'll need to think about and buy** if you set up as a cartoonist, we now come to the really **fun part–creating cartoons.** Over the following pages, each **double-page spread** works as **one lesson of the course,** explaining all the **essential techniques and skills** you need to become a cartoonist.

In this, the first part of the course, we'll show you how to construct your cartoons correctly, from faces and figures…

...through hands and feet and expressions...

...to animals, light and shade, and lettering.

Grrr... Wait until I catch that cartoonist! Where are my clothes?!

Every lesson will outline the **most important information** relevant to that subject and has **exercises** for you to try to help you **practice as you learn.** We'll start with the **basics,** such as figures and faces, and progress onto more **advanced lessons,** including light and shadow and special effects.

Figures

Figure work is the core essential to the majority of all cartooning. Almost every cartoon will have some sort of character or figure in it, whether it is a humorous human or an anthropomorphic animal. Figures can be used as composition, as mood setters, and as individual expressions of the cartoon idea.

The key to understanding how the human body works is through observation (see pages 74–75). Once a complete understanding has been reached, the body can then be transposed into cartoon form.

There are some basic rules to consider when drawing the standard human body, which, when used correctly, will always create the correct proportions in a figure. The height of the head should fit into the height of the body approximately seven and a half times, with the top of the leg about the halfway point of the figure. The average arm length, from shoulder to tip of the fingers, is three to three and a half times the length of the head. You can play with these rules to create a more comical effect by increasing the head size or extending the leg length, for example.

Draw simple ovals for the head, body, hands, and feet with stick arms and legs to enable correct positioning of the figure.

To start the basic, modular figure use guidelines in blue pencil (as this will not show up in reproduction) and create a central line that runs through the body. This will help you draw the right angle of tilt.

Start to build on the basic figure. Thicken the arms and legs; enter the more basic details such as the position of the face, hands, and feet.

Keep practicing getting the figure's **correct proportions** by using the initial stick figure's guidelines.

Try drawing the same figure from various points of view, including a full frontal, from behind, and turned at a three-quarter angle. This will give you an idea of how the same body can be perceived in different perspectives.

SEE ALSO

 Metonymic Distortion 32

 Expressive Figures 36

 Animals 44

 Working from Observation 74

As you **improve** you will be able to **gauge** the proportions naturally.

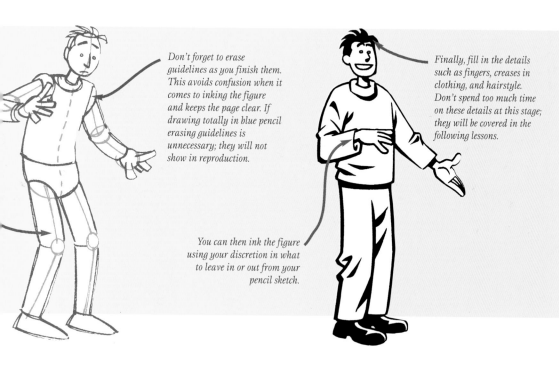

Don't forget to erase guidelines as you finish them. This avoids confusion when it comes to inking the figure and keeps the page clear. If drawing totally in blue pencil erasing guidelines is unnecessary; they will not show in reproduction.

Finally, fill in the details such as fingers, creases in clothing, and hairstyle. Don't spend too much time on these details at this stage; they will be covered in the following lessons.

You can then ink the figure using your discretion in what to leave in or out from your pencil sketch.

Over to you...

- Draw a variety of body shapes from large to short and thickset. Notice how the figure stays in proportion despite the variations.

- Draw figures in a variety of poses (sitting, standing, lying down) keeping the correct proportions. Note how the body changes.

- Think about the joints on a body and how they move, such as the ankle, elbow, and knee.

The modular figure will help you understand the body's proportions, but of course modular figures appear stiff, so try creating more naturalistic poses using the same sense of scale. Draw figures sitting down, walking, and eating, to help you understand how the body moves.

The modular figure can also be adapted for various body types. If you have a particularly tall figure, extend the length of the head. Similarly, a shorter or larger person would have various limbs reduced or thickened to keep their proportions accurate, unless a particular style was being aimed for.

Faces

There are a multitude of different shapes and sizes of faces, and all have their own distinct characteristics. The key to good cartooning is being able to draw a wide range of faces, each with their own instantly recognizable features. As with drawing the body, there are some basic rules to be followed.

Before starting on the facial features, you need to understand how the head is drawn and at what angle the face will be viewed. The head looks very different when viewed from various angles.

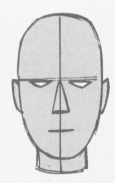

A head facing forward can be drawn as a basic oval.

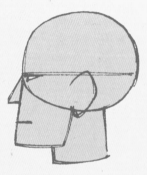

When drawing the side or three-quarter view, the oval is elongated toward the back of the head, with a box added at the bottom for the jawbone.

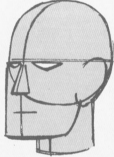

On three-quarter or side angles, the nose will protrude from the face, but face forward it will appear flat.

▶ Face front

Here are some examples of heads drawn from different angles. Notice how the rules dictated above still apply despite the different styles.

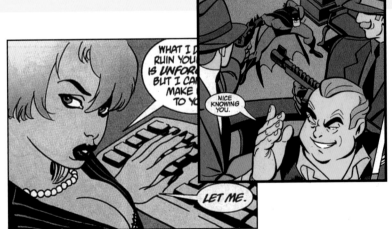

WHAT I D
RUIN YOU
IS UNFOR
BUT I CA
MAKE
TO YO

NICE KNOWING YOU.

LET ME.

BASIC ELEMENTS

The face is made of five basic elements: the eyes, nose, eyebrows, mouth, and ears. In a classic oval face, the nose is central and approximately one-third of the way up and the eyes are level with the tops of the ears.

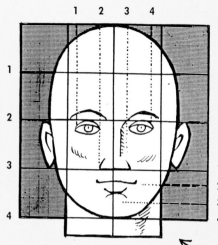

1 2 3 4

1
2
3
4

1
2
3
4

Draw a line down the middle of the face to help position the nose, mouth, and eyes. As the head is tilted, this line will change position.

Don't forget to curve the center line of the face in the direction of the head tilt. Also, keep the eyes, nose, and mouth evenly spaced when tilting.

1
2
3
4

Faces are essential to cartooning...

DETAILING FACES

The various elements of a face can also be repositioned to create different effects.

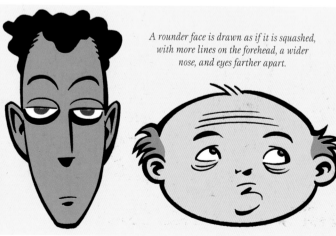

To draw a thin face, elongate the oval shape, tilt the eyebrows in a "∧" shape, raise them high on the forehead, and increase the distance between the nose and mouth.

A rounder face is drawn as if it is squashed, with more lines on the forehead, a wider nose, and eyes farther apart.

Over to you...

- Try sketching friends and family whenever possible. Look at their features and practice caricatures by exaggerating various physical attributes such as ears or eyes.

- Draw as many different faces as you can think of, from old men to young girls. What elements make each face unique?

- Build a database sketchbook of various types of faces, from thin, gaunt ones to rotund ones, to use as a reference. What sort of moods do different-shaped faces suggest?

...as they allow the reader to identify more readily with the cartoon.

Hands and Feet

Hands and feet can be equally as expressive as the face or the body, with a variety of gesticulations supplementing facial expressions, such as the clenched fist for rage or hands clasped together to represent pleading.

Hands and feet are often regarded as the hardest parts of the body to draw, and even the most experienced cartoonists have difficulty with them. However, if you follow these simple guidelines you will be well on the way to creating simple, yet expressive, hands and feet.

Remember that **even the best cartoonists** have difficulty in drawing hands and feet...

The hand is made up of four fingers and one thumb, and can be portrayed in a seemingly endless combination of poses. The best way to study the hand is to draw both its palm and its back. Note the differences: The back of the hand has prominent lumps where the knuckles and finger joints are, whereas the palm side has creases and lines in exactly the same places. The palm also has additional lines on it, and these can be used to give depth and form. The tips of the fingers, from both the back and the front, end with fingernails, and these can be used to add character by drawing them lengthened, polished, manicured, or bitten.

Start drawing a hand (palm side) as a stretched pentagon and add the thumb in an upward curve away from the palm. Remember that the thumb is approximately the same length as the little finger, but it is thicker and further down the hand, so it only appears to be shorter. Together they are the shortest digits.

Next, draw the middle finger (the longest) and use it as a scale for the other digits. The index and third fingers are approximately the same length, but they will appear different in naturalistic poses.

For more natural poses, try not to separate the fingers too widely. Crossing or overlapping fingers will lend a more realistic touch to any pose.

...so **keep practicing.**

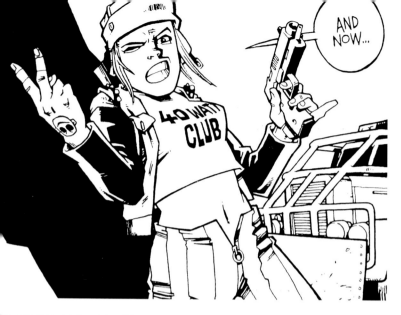

◄ In your face

This drawing of Tank Girl has an aggressive stance indicated by the two-finger gesticulation.

Over to you...

- Practice drawing a variety of hands in as many positions as possible. Long slender fingers would be better suited to certain jobs than short stubby ones. Try to draw these different hands coping with the same tasks.

- Convey various meanings and emotions via hand gesticulations. For example hands palm upward with fingers separated can suggest despair; a clenched fist with one finger outstretched suggests a point is being made.

- Draw feet in a variety of ways, from running or walking to kicking a ball, and note how the joints move.

DEPICTING FEET

Feet, when combined with leg positions, can express certain feelings, such as shyness or embarrassment when the feet are crossed. However, feet are less expressive than hands and are generally less drawn in cartoons because they are usually covered by shoes.

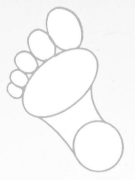

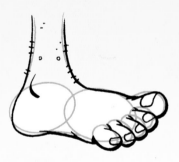

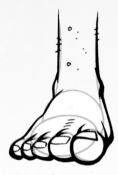

The base of the foot is the simplest angle to draw from and can be created by using two ovals—one for the heel and one for the ball of the foot—linked together with two curves. The toes can be built up from five descending ovals. Remember that the big toe is always on the instep.

The foot from a side view is slightly more difficult to draw, yet can also be created using two circles— one for the heel and one for the first big toe joint—linked with curved lines. The toes are again extended out using ovals given the necessary length. This basic rule can also be used for a natural-istic, three-quarter angle.

Feet viewed head-on are notoriously troublesome to draw since very difficult foreshortening is required. The toes are more circular when drawn facing forward, and the foot slopes inward toward the ankle and up to the leg almost seamlessly.

Metonymic Distortion

The natural human face and body can be adapted, when drawing, to create more interesting or comical characters. This process, known as "metonymic distortion," takes certain aspects of the standard, or modular, figure and twists, enlarges, or reduces them. Now that you know and understand the rules of body proportions, you can start to play around with and break those rules.

FACIAL DISTORTION

Facial adjustments can either elongate or squash the standard oval shape to create various types of faces.

Lengthening the nose and separating the distance between the mouth, nose, eyes, and eyebrows are all methods of creating the impression of a thin, tall person.

Alternatively, the size of the eyes could be increased to create the impression of a wild, staring character.

A wider, broader nose will imply a certain type of character or career (perhaps a boxer).

Use less line work in your cartoon than you would use for a life study. **Too many lines** on a character's face can give the unintentional appearance of aging and **distract from the essence of the drawing.**

SEE ALSO

 Figures **26**

 Faces **28**

 Perspective and Forshortening **68**

 Caricature **130**

BODY DISTORTION

Distortion is an important tool of the cartoonist, as by simple exaggeration of a body you can relay a characteristic with speed and impact. For example body distortion combined with abrupt foreshortening can convey mood and movement in action cartoons.

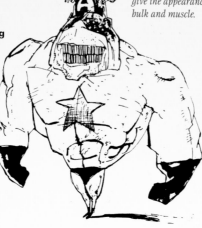

For tough characters, shorten the legs and torso and thicken the arms to give the appearance of bulk and muscle.

To create the effect of a taller person, try lengthening the legs excessively.

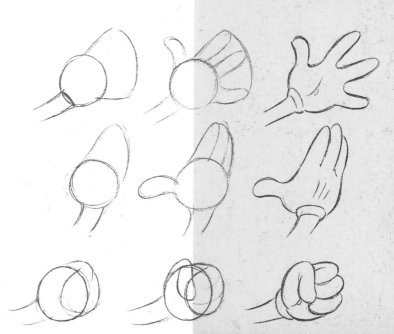

J'AI ÉTÉ REÇU COMME UN CHIEN DANS UNE JONQUILLE!

DANS UN JEU DE QUILLES!

C'EST CE QUE JE DIS!

More rounded figures can be created simply using a series of large circles or ovals.

Over to you...

- Draw a simple, normally proportioned character. Then imagine that he has gained 140 lbs and lost 3 feet in height. Take the same character and add 6 feet in height and make him skinny. Notice the difference in appearance while the person still remains recognizable.

- Draw situations where metonymic distortion could be used for comedic effect, for example, eyes popping out of the head or legs being stretched like rubber. Animated cartoons use these techniques all the time.

▶ **Hands on, fingers off!**

Many cartoonists reduce the hands down to stockier versions of their real counterparts, with thicker, chubby fingers. Often the number of fingers is reduced to four or three. When drawing hands in this way, reduce the number of lines you would use for a more realistic interpretation.

Expressive Faces

The face is the most expressive and important human feature a cartoonist needs to portray. Everything from anger, happiness, and fear to puzzlement, sorrow, and sickness can be expressed in a few simple lines on a face. Having mastered the basic rules for placing facial features and how to break those rules to create effects with metonymic distortion, the next stage is to learn how to illustrate the variety of human emotions. With this skill mastered, your range of characterization will be almost limitless and will allow you to use a wide visual vocabulary.

All emotions can be created by simply distorting and exaggerating the basic face. Individually, the basic facial elements (eyes, nose, ears, mouth, and eyebrows) can express a variety of emotions. The eyebrows can be raised in surprise or slope in a "V" shape to denote anger. The mouth can be tilted up or down to express joy or sadness. When these methods are combined, they can make up almost any human emotion. It really is as simple as piecing together an identity kit.

Even with the most basic of lines you can express a vast array of faces. See how many you can create using this same template.

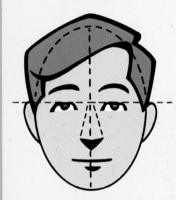

Here is a plain non-expressive face with no distortion, similar to the first one you drew on page 28.

Eyes widened with the mouth open, eyebrows raised, and beads of sweat with hair raised are all ways of drawing fear. The face will often appear paler from loss of blood.

Puckered eyebrows, frown lines on forehead, downturned mouth, and head in hands are all indicative of sadness and depression.

SEE ALSO

 Faces **28**

 Metonymic Distortion **32**

 Observation to Artwork **76**

 Working from Reference **80**

The **correct expressive face** will add **depth and character** to your work.

Surprise is often portrayed with raised eyebrows and an open mouth—usually small, but sometimes larger depending on the nature of the surprise and for exaggerated effect.

Over to you...

- Sit in front of a mirror and try to make as many different facial expressions as possible, and sketch them.

- Look at the faces you sketched earlier in this chapter (see page 28) and redraw them with various differing emotions.

- Create a scene in which several people are all reacting to the same event with very different emotions, such as a jury respondong to a lawyer's speech. See what effect they have on the overall cartoon.

The furrowing of the brow with teeth bared, either gritted or visible while shouting, increased stress lines, and a reddened face can all denote anger, as can a pouting mouth and narrowed eyes.

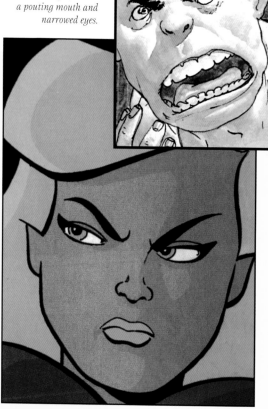

Happiness can be shown with a simple closed-mouth smile right up to a full teeth-bearing, face-filling grin. If the character is laughing particularly vigorously, you can narrow the eyes and add laughter lines around the eyes and mouth.

Curiosity or thought can be created by wrinkling the center of the face, furrowing the brow, or reducing or tilting the mouth.

Expressive Figures

Like the face, the body can express a wide variety of moods and emotions, and the two combined can create a powerful message. It is often said that people can speak volumes without opening their mouths, simply through body language. In cartoons, also, you can alter the overall sense using this unspoken communication. There are two main types of body language: posture (unintentional) and gesture (intentional).

Posture is often used as a clear indication of personality type or the current feeling of a character.

A superhero, for example, would have his chest pushed out and hands on hips, and be smiling with his chin lifted up. All of this indicates a very confident person, perhaps even arrogant.

Conversely, someone who is sad or depressed would be shown head down, looking at the floor, shoulders slumped, and arms hanging limply.

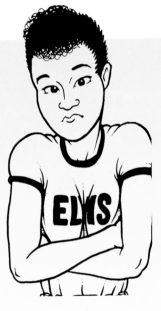

Someone who looks angry with arms crossed tightly may be defensive and hiding something.

Physical expression can be very **powerful**, and a whole cartoon strip can be told in nothing more than a **series of body language images**.

 Expressive Faces 34

 Drawing character: Cast 40

 Movement 48

 Maintaining an Idea Bank 78

SEE ALSO

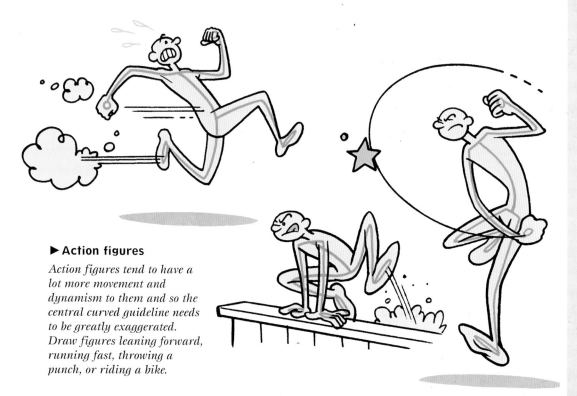

► Action figures

Action figures tend to have a lot more movement and dynamism to them and so the central curved guideline needs to be greatly exaggerated. Draw figures leaning forward, running fast, throwing a punch, or riding a bike.

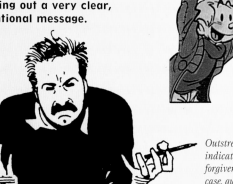

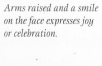

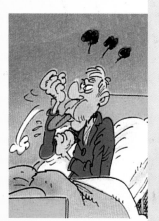

Over to you...

- Try to draw as many emotions as you can just through body language, from happy through nonchalant to depression.

- Place two very expressive figures together, such as a boxer and an opera singer, and see how they interact.

- Create a library of expressive figure drawings for later reference.

- Draw different body types doing the same activity. How do they react? A slim body may cope with swimming better than a short, stubby one.

DEPICTING GESTURE

The second type of body language, gesture, is far more conscious, and the person gesticulating is sending out a very clear, intentional message.

Arms raised and a smile on the face expresses joy or celebration.

Outstretched hands can indicate pleading, forgiveness, or, in this case, questioning.

This character's gesticulations indicate anger in no uncertain terms.

Clothing Figures

Now that you have your figures perfected, you need to work on putting some clothes on them. Considering that humans spend the majority of their time clothed, this is an important area to practice. If you get it right, clothing can add hidden depths to your cartooning.

A leather jacket can indicate a certain personality type, perhaps a rebel.

DEPICTING CLOTHES

There are just as many types of clothing material as there are types of people. Once you have selected the type of material you imagine the clothes are made from, you then come to the important part—how the clothes sit on the person.

Shoes that are highly stylized remove the need to draw realistic feet.

Clothes can be used as a "cheat" mechanism to conceal difficult body types.

The way light reflects off a shiny leather jacket will be very different from the way it reflects off a denim or cotton jacket.

A baggy jacket or suit will obscure most of a body's frame.

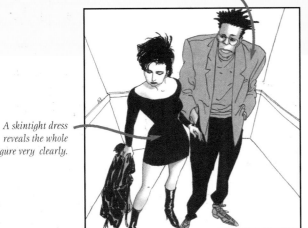

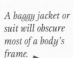

A skintight dress reveals the whole figure very clearly.

Large, black, shapeless clothes are good for hiding an awkward body shape.

Denim and cotton creases a great deal more than leather.

SEE ALSO

 Figures 26

 Drawing Character: Cast 40

 Drawing Character: Social Types 42

 Working from Observation 74

On this still figure, the clothes hang with no movement distortion. There are some creases in the jacket caused by the bunching or gathering of material

A messy character with a shirt untucked, holes in the sweater and shoes falling apart may indicate a tramp or an absent-minded professor.

Here the creases are predominantly around the knees, waist, and arms.

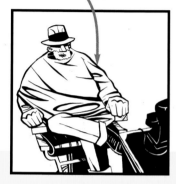

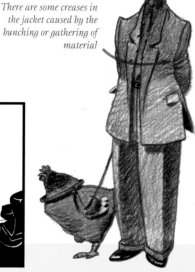

Consider the pose of the figure. Is the character sitting or standing, or is it engaged in some sort of movement or action?

If a figure is standing straight in a suit, the cloth will be stiff and angular, with sharp creases in the trousers. Alternatively, a long flowing dress on a woman will show subtle folds and waves in the material.

Clothes can also be used as indicators of character, since different styles of dress can denote a variety of lifestyles.

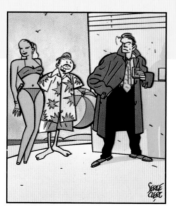

Note how the artist has exaggerated the creases where the knees and arms bend in the clothing, and where it swings freely at the limb joints.

As the body moves in different ways, it will stretch different material in some areas and loosen it in others.

Uniforms, of course, are a very clear sign of that person's career, whether a mail carrier, sailor, or airline attendant, and can instantly help clarify a person's role in a cartoon.

Over to you...

- Look at the clothes you are wearing. Examine where the creases are and what is causing each crease—an arm or leg—or even where the sleeves or pant legs have been rolled up and bunched.

- Think of five very different jobs and how the people who perform them are dressed, then draw them. For example, you might show a jockey wearing a silk, patterned shirt, jodhpurs, riding cap, long boots, and carrying a whip.

Clothes are an important indicator of character and should be thought about carefully.

Drawing Character: Cast

Now that you have mastered the individual skills of facial and figurative expression and metonymic distortion, it's time to bring all the elements together to truly breathe life into your characters. As cartoonists are essentially storytellers, each character or scene you draw should serve to advance the story line.

CHARACTER TYPES

Think about the types of characters you need for your cartoon. Do you need a tall basketball player and a short jockey? Or perhaps you need a very trendy street kid and a staid, conservatively dressed, middle-aged woman. Whatever you choose, you will need to distinguish between a variety of body types, from bent-up old ladies hobbling with walkers to sprightly young boys jumping around.

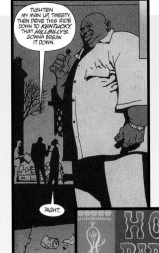

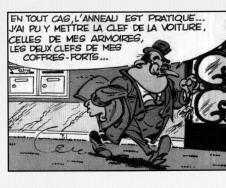

BODY LANGUAGE

Once you have the body shape planned, think about the body language. Is the boy waving his hands in the air or covering his face? Is the old lady shaking her fist or waving? As these elements come together, the cartoon will begin to come alive.

EXPRESSION

Start to think about the face—not only the physical aspects such as wrinkles or acne, but the expression as well. Despite her withered appearance, the old lady may actually be laughing, with a big smile on her face, and the boy may be expressing surprise and shock.

CLOTHING

The final touch is the clothing. Swapping unexpected clothes on various character types can create amusing twists, for example having a little girl dressed as a soldier or an old man dressed as a little girl. Such twists will throw off the reader's preconceptions and draw the reader in.

Over to you...

- Draw a scenario such as a ship or office and populate it with three to five very different characters; don't forget to mix up the sexes and racial types.

- Think about the personalities of your characters and how they should be reflected physically.

Remember, there is an **endless combination** of faces, body types, expressions, and clothing to draw from. **Experimentation** will reveal **matches previously not thought of.**

Drawing Character:
Social Types

From what you have learned in the previous pages about creating the cast of your cartoon, you should now be able to define their personalities and backgrounds. Think about the clothing, hairstyle, and general appearance of each character and try to fit each character into its own societal role.

By drawing from observation (see pages 74–75) you will be able to see how various members of society act and compose themselves. Whether it is professionally, or through class, age, or ethnic groups, each of your characters should be able to fit into one, if not more, of these categories.

The wonderful thing about creating your cast is that you are open to an endless range of possibilities, from Japanese tourists and Olympic athletes to skateboarding teenagers and suburban housewives.

▶ **Job hunt**

Decide what sort of jobs the characters do. Jobs can be identified easily if the characters work in the labor or service industries, as many wear a uniform (see pages 38–39), but if they work in a creative or business field, depicting a job through clothing may be a bit more subtle. Think about friends and their jobs and visualize how they dress for work.

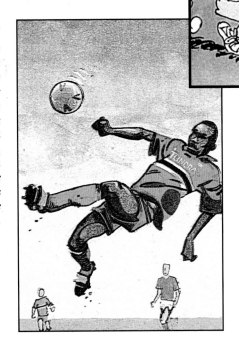

Never forget that there are an **endless variety of people** in society.

SEE ALSO
Drawing Character: Cast **40**

Working from Observation **74**

Working from Reference **80**

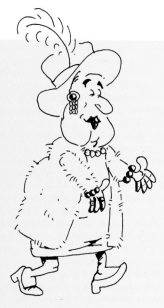

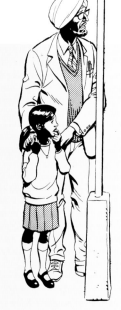

Characters belonging to a definite societal class are the easiest to create because of their obvious natures. For example, a rich character could be drawn as dripping in jewelry and wearing a fur coat.

A destitute character might be wearing dirty clothing with holes in it, and have messy hair, no shoes, and be unshaven.

Some ethnic characters, such as Sikhs, will be instantly recognizable (through the turban and beard in this case), while Afro-Caribbean characters can be highlighted using hairstyles and skin tones, if working in color.

Over to you...

- Draw several socially different types of characters in a single scene and think of situations that might throw them together, such as an aiport or a railroad station.

- Imagine what stereotypical professions would look like, such as a chef in a kitchen who may be depicted as rotund, with a large, sweating face; or a police officer who could be illustrated as a tall, well-built, authoritative figure.

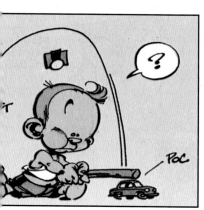

◀▶ The Ages of Man

Age is easy to portray because the visible differences in ages, from babies and toddlers through to the very old, are blatant. However, these subtleties get less distinct with people in their twenties, thirties, and forties. The key to dealing with age is facial lines. For example, a baby's face should be kept as clean as possible, with very few lines on it. As characters get older, additional lines can be added slowly around the eyes and jowls, but be careful not to overdo it or they will end up looking tattooed!

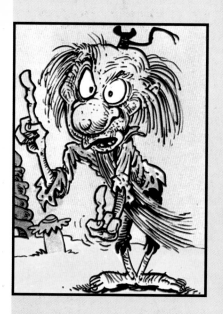

Animals

Cartoon animals can be created in relatively short steps, following some basic rules. Study various animals in real life and in photographs and emphasize their most prominent features, whether it is an elephant's large ears and trunk or an ant's antennae and six legs.

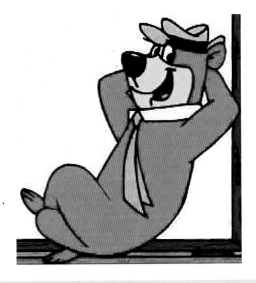

▶ **Bear naked!**

The hat and tie that Yogi Bear wears and the erect stance he takes all make him appear more human.

Using the same principle as human figure creation (based on circles, ovals, and lines) build up the animal's basic shape and then begin to flesh it out by adding weight and detail. The key difference between a cartoon animal and a life study is the face. Often an animal's face is impassive and is, therefore, difficult to read any character into. With a cartoon animal the face needs to be very expressive, often more human than animal. This expression, or imposition, of human characteristics onto animals is known as anthropomorphism and can be expressed in many different ways in cartoons.

You can draw an animal—a bear, for example—with a humorous face, who uses the same body language as humans. He can ride a bike, walk on two legs, and sit at a desk, but apart from the cartoon face he looks like a regular bear.

Or you can take the bear with the standard physical attributes—claws, fur, and so on—and draw clothes and hats on him, or have him hold a musical instrument. This takes the bear one stage closer to being human without losing the essential "bearness," much like Yogi Bear in the Hannah Barbera cartoons.

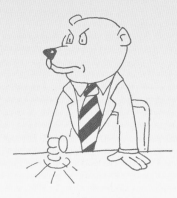

Another alternative is to take the bear's head and place it on top of a human body, thus creating a hybrid that still looks like a bear but has the mobility of a human. The legs, arms, and hands can look human or have bear attributes, such as excess hair or fur on the arms.

SEE ALSO

 Figures **26**

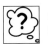 Metonymic Distortion **32**

 Working from Reference **80**

ANTHROPOMORPHIC ANTICS

You can also take various modular elements from different animals to create new fantasy creatures or apply them to humans to give them a more animalistic appearance.

▲ **Fantasy animals**

The animals pictured have a variety of human and animal attributes.

While they have human hands, the pheasant and tapir still have traditional animal feet.

The clothes and the car give the animals an air of humanity. Note the zebra stripes on the car.

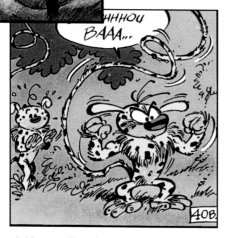

◄ **Bear scare**

This koala bear still looks like a normal bear, but his expression of surprise and erect position have a recognizably human quality.

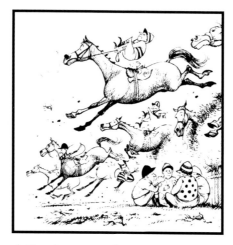

▲ **Horsing around**

Look closely at this classic equestrian cartoon by Thelwell. Each horse has its own distinct expression, as do the jockeys.

▲ **Marsupilami**

The late Belgian cartoonist André Franquin created the humorous Marsupilami *using various elements from other animals, including a monkey's body and tail, a leopard's coloring, and rabbit-like ears.*

Over to you...

- Study various animal shapes and bodies. What sorts of characters do their bodies suggest? A slow, dim-witted elephant or a fast, wise-talking duck?

- Look at various human faces and try to fit animal characteristics to them. Remember the cliché that owners look like their dogs. Go to the park and draw a pet's key features onto its owner. A jowly, old, retired major may be reminiscent of a bulldog or a bloodhound, whereas a tall elegant woman may look like an Afghan hound.

▼ **Farmyard funnies**

Here, the animals are a mixture of traditional looking pigs and other farm animals with expressive faces and a cat and rabbit that are walking erect.

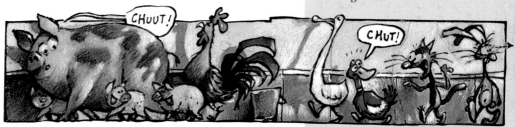

Light and Shadow

Using lighting in your cartoons is always very effective if you need to develop tension or create a mood. Many cartoonists use light and shadow to heighten the reading experience, and depending on your use of lighting, you can evoke many sensations in the reader.

In order to use light and shadow well, you must understand the concept of light sources. Look around you now. Can you see in which direction the light is coming from and how it creates shadows in the opposite direction when something blocks it? This basic concept is your key to creating evocative cartoons. Once you grasp the idea of light sources and how they throw shadows, you can begin to use and exaggerate them for your own purposes. Whether you stay completely naturalistic in your lighting or you overstate the light sources and shadows to create a sense of heightened reality is up to you, but take a look at these examples to see some different approaches.

Applying **lighting** to your cartoons will allow you to help **create a response in the reader.**

LIGHT SOURCES

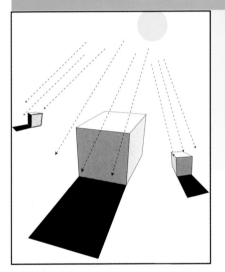

In this diagram we can see the effect of a light source on a cube: The side that is opposite the light is darker than the rest of the cube, and the cube throws a shadow behind this dark side.

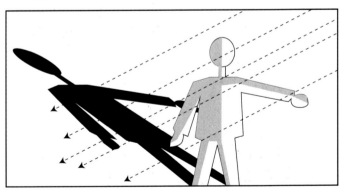

Just like the example of the cube, here we see the effect of light striking a figure. Note that the side that is not directly in the light is shaded, and also note the shape of the thrown shadow.

SEE ALSO

 Special Effects **50**

 Working from Observation **74**

Pens & Markers **90**

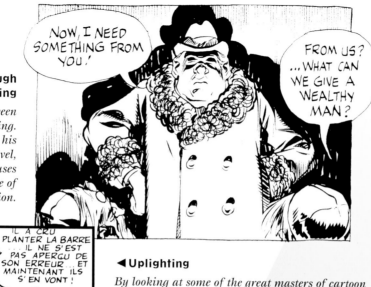

> NOW, I NEED SOMETHING FROM YOU!

> FROM US? ...WHAT CAN WE GIVE A WEALTHY MAN?

▶ **Tension through lighting**

Will Eisner has always been known as a master of lighting. Here, in this example from his groundbreaking graphic novel, A Contract with God, he uses lighting to create a sense of dramatic tension.

> IL A CRU PLANTER LA BARRE ...IL NE S'EST PAS APERÇU DE SON ERREUR... ET MAINTENANT ILS S'EN VONT!

◀ **Uplighting**

By looking at some of the great masters of cartoon art, we can see the practical applications of light and shade. This panel is from the great Argentinian cartoonist Alberto Breccia's strip Mort Cinder. *Note how he uses light and shadow to create a very evocative effect.*

> WHAT THE HECK IS THAT ALL ABOUT?

> LOOKS LIKE WE'RE GOING TO FIND OUT REAL SOON, BOYS—

▲ **Light versus dark**

The great Alex Toth uses a similar balance of light and dark to create his drawings, to a startling effect.

◀ **Chiaroscuro**

The late André Franquin, a Belgian cartoonist known for his humorous material, created a series of dark parodies called Idées Noires, *that was unlike anything he'd done before. Here he uses a lighting effect called "chiaroscuro" (a manipulation of light and dark areas) to cause an unsettled feeling in the reader.*

> NON!

Over to you...

- Look at the examples shown here and try to ascertain where the light is coming from in each one. Also, try to figure out where the shadows will fall if the light is moved.

- Draw a simple figure and photocopy it a number of times. Then, using pencils or pens, draw a different light source or sources on each one, and their corresponding shadows.

- Using a flashlight in a darkened room, try looking at yourself in a mirror with the light coming from different directions. Or, get a friend to do the same thing while you make quick sketches.

- Try sketching people, trees, and buildings at different times of day to see the effect of the height of the sun on shadowing.

- Look at how light reflects off glass, particularly in cars. Also note the shadows thrown both inside and outside a car on a sunny day.

Movement

The real art of a cartoonist is being able to make a static image appear to 'move'. But many artists, from Marcel Duchamp and the futurists to present day cartoonists, have found this extremely challenging. Luckily, cartoonists are ahead of the game, as the illusion of movement is something that has been well covered in comics and cartoons.

Movement in cartooning has typically been evoked by the use of a device called the "motion line." This essential part of cartoon vocabulary consists of lines drawn around objects in motion, whether stretching behind a running man or around a wobbling vase. This piece of stylization has grown in complexity and variety as cartooning has matured, and indeed, it has taken on different forms in different countries. In Japan, in particular, the motion line has seemingly taken on a life of its own (see example below). There are other methods for signifying movement, but none of these have the ubiquity of the motion line, or its expandability. Of course, if the drawing doesn't reflect the type of movement that it is supposed to be depicting, then all the motion lines in the world won't help. Indeed, if your line is lively enough, and your chosen pose of expression is good enough, then you may find that you needn't use motion lines at all to create a sense of movement.

<div style="writing-mode: vertical-rl">MOTION LINES</div>

When using motion lines, always show the lines coming from the object in motion, usually by drawing the lines away from the moving object.

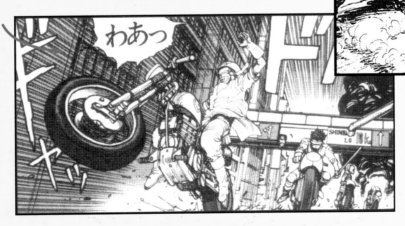

In Japanese comics, or Manga, we see perhaps the most extreme use of the motion line. Here, in this panel from Otomo's Akira, *instead of the subject of the panel moving, the background is drawn with motion lines all around to signify that your attention is on the subject and not the moving background.*

In this Vaughn Shoemaker cartoon we can see the excellent use of motion lines to represent movement. Note how the motion lines follow the movement of the cat-o'-nine tails as it moves through the air. In this way, Shoemaker has depicted the violence and speed of the stroke delivered to the poor wretch on the ground.

SEE ALSO

 Figures **26**

 Special Effects **50**

 Working from Reference **80**

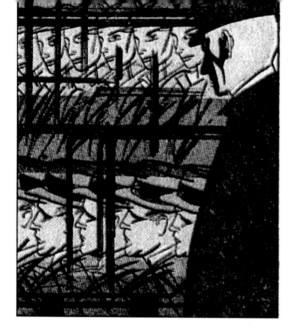

◄ Multiple image as movement

In this panel from the classic strip Master Race, *drawn by Bernard Krigstein, we see another method of showing movement. The passengers in the moving subway train are shown as multiple images, while the character in the non-moving foreground is shown as a single image.*

Capturing **movement** in cartoons is the art of **turning space into time.**

▼ Action lines

This panel from Jack Kirby, an American comic book artist for over three decades, shows the motion line at its most action-packed. The motion lines fly out from the central figure and show the path that the movement takes through the panel. The background and the protagonists are drawn clearly, with the motion lines seeming to "overlay" them all.

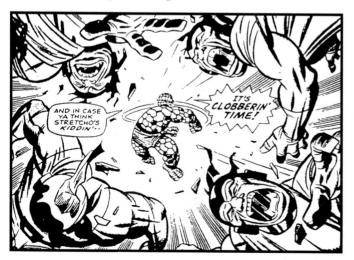

AND IN CASE YA THINK STRETCHO'S KIDDIN'—

IT'S CLOBBERIN' TIME!

I KNOW IT WASN'T ALWAYS A LOT OF FUN, BUT WE LIVED THROUGH IT, AND WE GOT TO SPEND SOME TIME TOGETHER, AND THAT'S WHAT'S REALLY IMPORTANT.

▲ Shadow as movement

Using shadows beneath an object in motion can be very effective, as in this panel taken from Bill Watterson's Calvin & Hobbes *newspaper strip. The car that Calvin's family are riding in is clearly in motion, yet there are no motion lines. The shadow under the car and the attitude of the wheels tell us all we need to know.*

Over to you...

- Look carefully at how your favorite cartoonists portray motion.

- Photographs are often a good reference for moving objects. Look at how photographers can either show the object in motion or the background as a blur, according to the shutter speed they use. Try tracing some action photographs and placing motion lines on them to simulate the same effect.

- How would you show:

 A man in motion, running for a moving bus?

 A car going around a corner?

 A dog catching a thrown frisbee?

 A woman breaking a heel on her shoe?

 Someone bumping into a table and almost knocking over a cup?

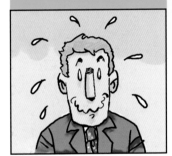

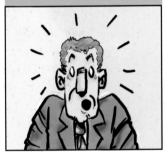

Special Effects

One of the most profound things about cartoon art is its ability to make the invisible visible. The fact that cartoonists have developed a massive vocabulary to signify different emotions and states of mind and body is a massive bonus to the effective communication of ideas from the cartoonist to the reader. Among these techniques, special effects are especially valuable.

The most obvious of these special effects are word balloons. With word balloons we can show speech and thought in a silent medium. We will be dealing with these in more depth in the next lesson.

Some other popular special effects are illustrated below. What all these devices have in common is the ability to transmit information instantly and efficiently to the reader. Interestingly, many of these special effects don't have "proper" names. So, in the early 1980s, American cartoonist Mort Walker, creator of

Beetle Bailey, set about naming the most used special effects for his own amusement in a book called *The Lex(icon) of Comicana*. These names, while not exactly scientific, caught on with some cartoonists and are still in use today—and we will refer to them throughout the following examples.

Of course, the beauty of these special effects is that you don't have to stick to the commonly used ones. If you have a better idea for portraying an emotion, go for it!

EMANATA	PLEWDS	GREAT IDEA	SQUEANS

One of the more common effects is a number of lines radiating around the head to symbolize shock or surprise. Walker called these "emanata," and they can be very useful.

A variation on a theme is the radiating sweat beads, or "plewds," shown when someone is working hard or is very worried.

If you want to show someone having a great idea, then the "lightbulb-above-the-head" effect is a great one to go for. You can frame this in a thought balloon or just leave it by itself.

Another variation on the emanata theme is the "squean," used for showing intoxication. Squeans can either be little starbursts or little circles.

▶ Squeans in action

This drunk legionary from Asterix and Caesar's Gift is very expressive with his tongue hanging out, stooped posture, and waving arm.

Taken together, these **effects** become a kind of **cartoonists' shorthand** for describing **the hidden or the invisible.**

Over to you...

- Look at your favorite cartoonist's work and try to find all the different types of special effects they use and how they use them.

- Think of situations where you could use the same effect to mean different things. For example, you could use a sweat bead to show fear, concentration, or anxiety.

- Just because many cartoonists use the same symbols doesn't mean you have to. Can you think of better symbols to use instead?

- Draw a face, photocopy it many times, and use different symbols to show different things. Does the symbol work well on its own, or does expression also play a part in signifying the emotion shown?

BRIFFITS

Some cartoonists like to show clouds of dust, or "briffits," to signify movement.

BAD DAY

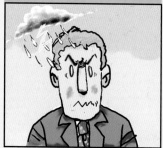

If you want to show your character having a bad day, then why not try using a thundercloud above his or her head? Don't forget the lightning bolt and rain.

LUCAFLECT

Using a "lucaflect," or reflection of a four-paned window, can show that something is either new or shiny. It doesn't really matter if there are no four-paned windows around!

Cartoon Texts

Although cartoons don't have to have any textual element to them, they usually do. In panel cartoons, the text (which may be dialogue, interior reflections, or just descriptive) is often printed underneath the cartoon as a kind of libretto. In comics, however, text appears mostly inside word balloons, a device that has been with us for centuries, according to some scholars.

In this section we will be dealing mostly with comics, as this is an area of cartooning that uses textual elements as part of the composition of the form itself. Text is handled in several distinct elements within comics, even though there may be some crossover. Additionally, the text is usually hand-lettered, but the use of computer fonts made to look like hand-lettering is becoming more popular.

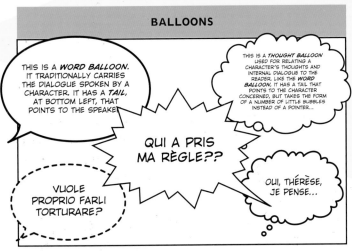

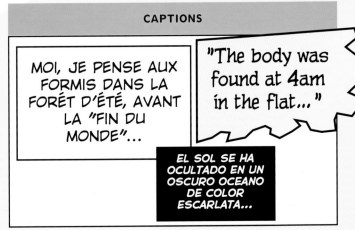

Captions are boxes that can contain a variety of textual elements. They may be used for description or scene-setting (although this can be redundant if you've already drawn the scene), internal dialogue, external dialogue, or a counterpoint in words to the scene we see in the picture.

External dialogue (speaking) is often enclosed within a word balloon with a pointer or tail toward the speaker. Internal dialogue (thought) is usually contained in a variation of a word balloon called a thought balloon. These usually have a scalloped edge, making them look a little like a cloud, with a trail of circles leading toward the person who is thinking. Word balloons can have different edges to show different types of speech, such as shouting, off-handedness, and whispering.

Never forget the **textual element** of your cartoons and the way it **interacts with the picture element.**

SEE ALSO

 Painting (or Bitmap) Programs 118

 Comic Strips 132

 Advertising and Packaging Illustration 136

DIGITAL LETTERING

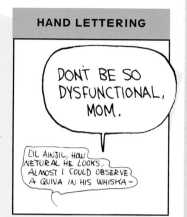

Some years ago, a British letterer, Richard Starkings, digitized his lettering style with a computer, and computer-lettering was born. The advantages of computer-lettering are obvious: It's less time-consuming, it's always legible, and it's as easy to do as type. Less obvious are the disadvantages: It can be bland, and it's not very distinctive if you use the same font as everyone else. You can buy computer-lettering fonts or download some free ones from the Internet (see page 155), but the best way to make your own is using a program called Fontographer. Be warned, however, that this is not an easy option. Creating a decent font that works properly is a lot harder than it appears, and can be very time-consuming.

HAND LETTERING

Hand-lettering is a skill that should be learned by all cartoonists, whether they have a computer or not. Good hand-lettering is individual and can really add to the visual style of the cartoonist, but it is time-consuming and can be somewhat of a chore.

Over to you...

- Practice your hand-lettering. Write out the upper- and lower-case alphabets (along with numbers and symbols) over and over. Remember that hand-lettering is a case of drawing the letters and not just handwriting.

- Look at lettering from everywhere. Make a study of typography, and learn as much as you can about letters as drawings and objects. Not only will you be a better letterer, but you'll also be a more well-rounded cartoonist.

- If you have a computer, you can experiment with computer-lettering by downloading some of the free fonts available on the Internet.

LOGO

Most strips have a logo of some form or other. These are most often used in titles or on covers. A good logo can create a real sense of anticipation and recognition in the reader.

SPECIAL EFFECTS LETTERING

Another component of comics that can be overused, SFX (or special effects) lettering is usually used as onomatopaeia (words that read like sounds). The lettering is often "animated" to follow the source of the action or to reinforce the impact of the words.

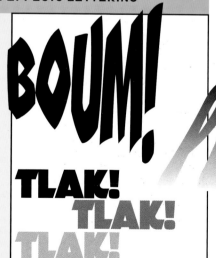

Chapter 3
Cartoon Composition

Composing cartoons is a critical part of the process. Without a clear and competent composition, your cartoons will not **impart the relevant information** to the reader and will therefore fail. **Elements of composition** that need to be **carefully considered** include **viewpoint** (where are we viewing the action from?);

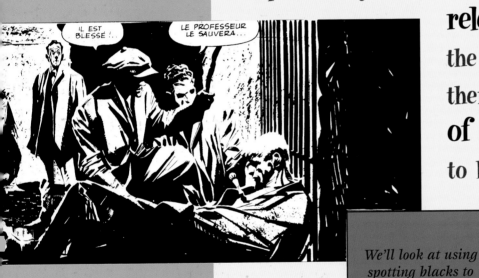

We'll look at using spotting blacks to aid composition...

focus (what are we looking at?); **graphic weight** (how to accentuate elements by line,

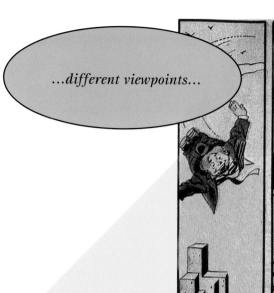

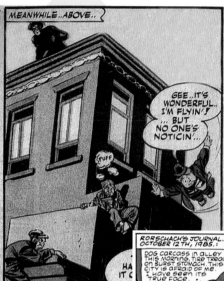

…*different viewpoints…*

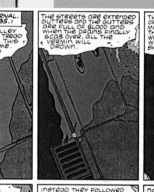

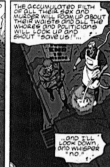

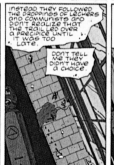

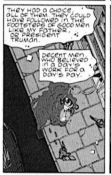

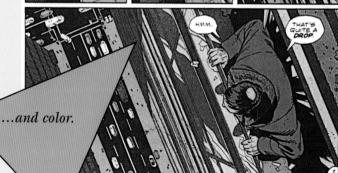

…*and color.*

shade, and color); **creating interest** in the foreground, midground, and background of your cartoons; **perspective**; and **scale**. In the following pages we will look at **how to stage compositions for the best effect** and **how different compositions can change the whole focus** of your work.

Graphic Weight

Graphic weight is the term used to describe the way some images draw the eye more than others, creating a definite focus. You may have noticed that large objects in a cartoon stand out more than smaller ones and engage the eye first. Similarly, saturated (or brighter) colors and the use of contrasting tones draw the eye even more.

Using the image area to draw the eye is the basis of all composition and can aid a cartoonist greatly in getting a point across. If we look at a blank page, we can see that even before any picture elements are introduced, the center of the page has the most weight. Any picture element placed here will draw and hold the viewer's eye. We can alter the focus of the composition by adding other picture elements and changing their weight using size, color, line widths, or patterning, so that it is no longer the central element that is graphically heaviest.

GRAPHIC WEIGHT IN PRACTICE

Consider a blank page. Even before an image is introduced the area has a well-defined "center of gravity."

The center of gravity is graphically the "heaviest" part of the area and a figure placed here will hold the reader's eye.

If all other variables are constant, a larger image, placed anywhere on the page, will be the stronger, and graphically the "heavier" part of the image.

Adding a sense of **"weight"** to elements in your cartoon will **help the reader understand your work.**

SEE ALSO

Inks **88**

Brush Rendering **94**

Tone and Color Principles **100**

TONAL DIFFERENCE

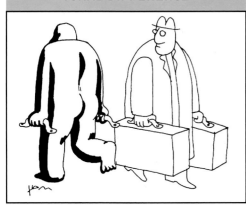

It is not always feasible to make the heaviest element in the image the largest, so there are other ways to change the weight of a cartoon's elements. One way is tonal difference, which refers to the use of light and dark shades of color. A dark-toned or more contrasting image draws the eye more than a lighter or less contrasting image.

USING PATTERN

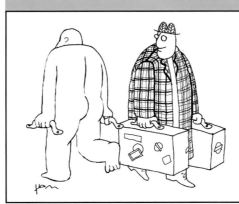

The use of patterns, a repeated series of marks, is a good alternative to tonal difference that has the same effect.

USING COLOR

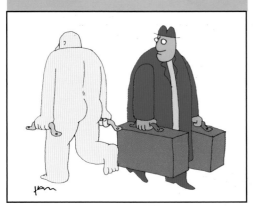

Clever use of color is also a great way of showing graphic weight. More saturated colors will always outweigh less saturated colors on the page.

RENDERING

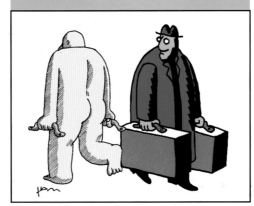

Rendering that uses less tonal variation, like ink washes, is more effective at drawing the reader's eye than finer, more intricate rendering.

Over to you...

- Using an image of two characters, try different ways of creating tonal variation to see which creates the greatest weight.

- Think about how you would use graphic weight to impart information to the reader more effectively, either in a storytelling sense or a purely graphic sense. Play around with variations in size, tone, color, and positioning to create different effects within your images. How would you create a sense of menace, for example?

- Try breaking the rules. Can you make a smaller figure outweigh a larger one through color, positioning, or rendering?

Foreground

When we look at the composition of an image, we can see that the picture can be broken into three distinct areas: foreground, midground and background. By understanding and utilizing these three areas we can create interest and focus in our cartoons.

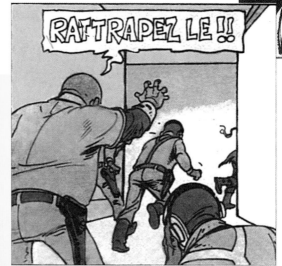

Let's take each element of the picture plane in turn. First, we'll look at the foreground. As the name suggests, the foreground is the area of the image that appears closest to the reader. Although most action and events in cartoons and comics will appear in the midground, it's in the foreground that the closest interaction with the characters or scene occurs. For dramatic, humorous or emotional impact, the foreground of your composition cannot be beaten. But, like most good things, it can be overused, therefore ruining the effect you may be striving for. So how can we put the foreground of our compositions to good use without overdoing it?

▲ Creating Viewpoint

Placing your characters in the foreground of your image can weight the impact of your cartoon in a number of ways. Here, the characters in the foreground are looking into the image, providing a kind of window, and showing their viewpoint to the reader. The same effect can be obtained using scene elements such as furniture or buildings and is good for framing your scene.

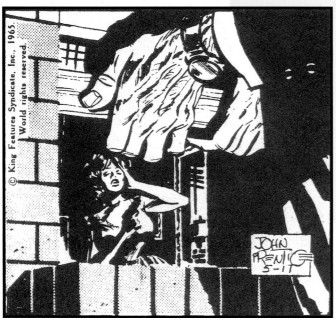

◄ Creating tension

Here, placing the hands lifting the window in the foreground creates an undeniable sense of menace and foreboding.

SEE ALSO

 Midground 60

 Background 62

 Viewpoint 64

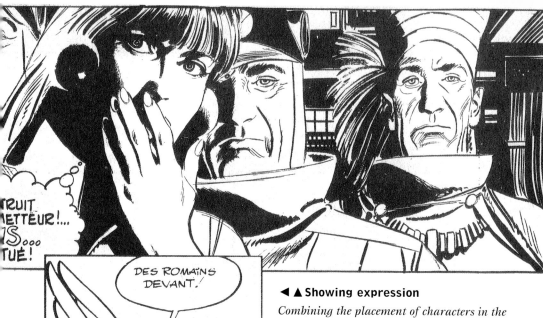

RUIT
METTEUR!...
IS...
TUÉ!

DES ROMAINS DEVANT.!

◄ ▲ **Showing expression**

Combining the placement of characters in the foreground with a close-up on those characters creates a subjective viewpoint. This is a useful technique for showing emotions or surprise.

Over to you...

- Draw a cartoon of a person receiving excellent exam results, practising using the foreground to show the emotion of your character. Be sure to include relevant background elements in order to avoid overwhelming the foreground to the detriment of the rest of the composition.

Like most elements of cartooning, less is more when using the foreground.

BALANCING THE FOREGROUND

Never use too many extreme foreground elements in the same composition, or series of compositions, as this can confuse the reader and make the natural flow of the image seem stilted or forced. If you need to show the midground or background as well, make sure you have enough room to get all the elements in.

Although painted with some skill, this image has too many elements in all parts of the picture plane, making it hard to decipher. There is also no real definition between the three areas of the picture plane.

- Try to think of cases where you could show an important event in the foreground that the characters elsewhere in the composition cannot see. This will allow your readers to really feel as though they are a part of the events taking place.

The panel layout also adds to the confusion due to the placement of the panels and their similarity to other elements of the image's composition.

Midground

While in compositional terms the three picture planes—fore-, mid-, and background—have equal weight and really should be considered as a whole, the midground is, in practice, the most used of the three planes. This is because most of the "action" in your cartoons will be situated here.

The midground is a convenient place to "center" your composition since this position allows the flow of the eye around the image to stop at its natural resting place. The use of the midground also allows for a more objective view of the proceedings in your cartoons. This doesn't mean you can't use the midground to focus on a character's reactions or emotions, but it is a particularly good plane to work with if you need to create a sense of "distance."

Setting your **action in the midground...**

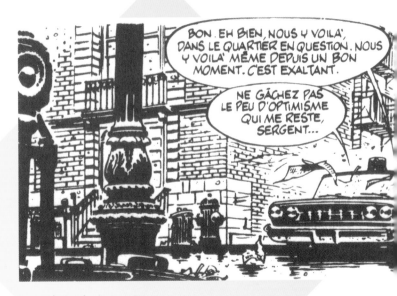

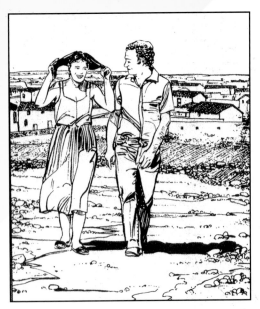

◄ Spatial relationship

Siting your characters within the midground takes some thought. Things to look out for include the relationship of the characters to their surroundings (are they to the same scale, for example?) and to each other (is the character on the left of the composition speaking first?). Does their posture relate to the scene they're carrying?

▲ Setting the scene

Furnishing the scene when using the midground is very important. Setting your characters in the right surroundings can often add to the reality of the cartoon. Is the cartoon set outside? If so, is it in the country or the city? Is it set inside? If so, is it in a home or an office?

...**gives** the reader **a general overview.**

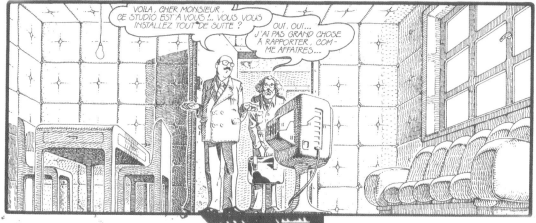

Over to you...

- How does changing the angle you view a scene from change how you site the characters within that scene's midground?

- Remember that the midground will be the major focal point in most of your work, and as such should be carefully considered when composing your cartoons.

- The midground doesn't have to be staid and dull. With a little imagination it can open new areas of creativity in your work. Study a wide variety of cartoons to discover different ways of addressing the midground.

▲ A sense of "reality"

Try to think of the scene as a whole. Does the siting of the focus of the scene in the midground fit in with the total composition of the image? How can the shifting of elements within the midground affect the whole composition?

By placing the world leaders in the midground and foreground, Briggs' effectively creates a sense of focus for the page as a whole, while never undermining any of the other page elements

MIDGROUND IN PRACTICE

This image from Raymond Briggs' masterwork *When the Wind Blows* is a wonderful example of the use of midground in cartooning, which would be almost impossible to recreate in any other medium than montage. Note how he composes the picture to be clear and concise, but not plain, and how the images of the world leaders at the time of World War II seem to float over the panels, effectively making them part of the panel's background.

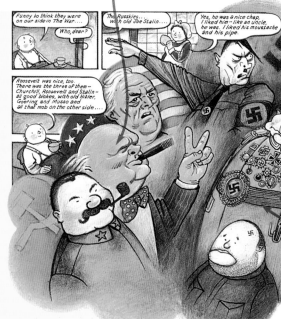

Briggs' use of the midground shows the dynamism that can be achieved with expert use of this picture plane.

Background

The last, but by no means the least, of the three picture plane elements is the background. Often important for establishing the scene of your cartoon, the background can also be used as a handy device for imparting additional, subtextural information to the reader.

Setting the scene with the background of your cartoon is vitally important in allowing the easy transmission of your ideas to the reader. The background can be as complex or as simple as you want, but you must be aware of its effect on the total composition of your image. We will come back to this a little later when we talk about perspective (see pages 68–69), but a concept to get to grips with here is the horizon line. This is the imaginary line where the sky meets the earth, and it is always at eye level. Good use of the horizon line can be invaluable for positioning your background elements and your characters in the correct proportion. For instance, if you had a character looking up at a building in the distance, where would you place the horizon line to ensure that the juxtaposition of all the picture elements made sense?

Putting the **background** of your cartoon to good use can help **create an evocative setting** for your readers.

▶ **Setting the scene**
By placing recognizable elements in the background, we can impart important information to the reader about the area in which the scene is taking place. Additionally, we can create areas of interest that counterpoint the action in the other parts of the picture plane.

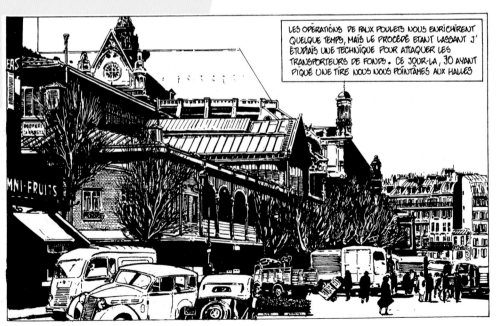

In this panel from *Spirou and Fantasio* by Tome and Janry, we can further appreciate the excellent use of the horizon line.

The use of color and an intricate background image really sets the scene in this image, imparting necessary information to the reader.

By using the horizon line low down in this panel's composition, the artist has added to the sense of scale between the character and the house. This sense of scale is also backed up by the inclusion of another car in the background.

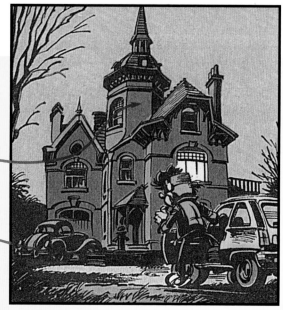

Over to you...

- Have a look at different cartoonists' work to see how they use backgrounds.

- Think about the background of your cartoons. Can you think of places where you can leave out a background, and still create a sense of setting for your readers?

- Don't just look at other cartoonists to learn about backgrounds. Look at paintings, television, movies, and other forms of visual art to see how they frame their compositions.

◄ Creating a "world"

Here we can see where the cartoonist has used the background to establish the setting for the scene. Panoramas like this can prove invaluable when you want to draw the reader into the "world" you are creating.

► Background emotion

Backgrounds, like the other elements of the picture plane, can be used to lend different effects to the cartoon. Here, the heavy use of blacks in the background creates a sense of darkness and suspense.

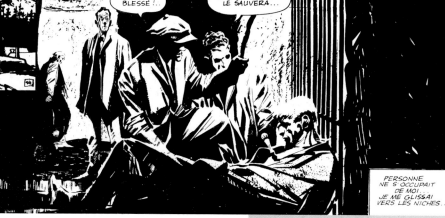

Viewpoint

Manipulating elements within the picture plane aids the composition and helps convey information to the reader. However, it is just as important to step outside of the picture plane and look at the viewpoint of the readers themselves.

Just like every other element of the composition, you control the exact point that the reader "sees" the action from. Additionally, like every other part of the composition, this viewpoint can be changed to affect the reader's experience of the cartoon. Even though cartooning is older than film, the prevalence of film in our culture has led to certain terms being co-opted by the cartooning community, and nowhere is the appropriation of film terminology greater than in discussing viewpoint. Thus, cartoonists often talk about close-ups, bird's-eye views, and wide establishing shots. But what does all this mean for you?

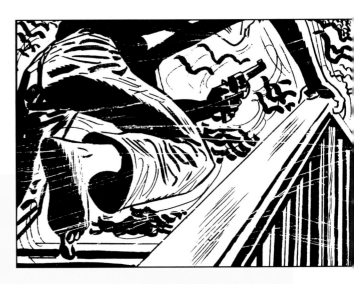

▲ Part of the action

This is a close-up viewpoint. The reader is made part of the action and sees what's going on as if he or she were one of the participants.

◄ Exciting?

The use of viewpoint can heighten the reader's experience and enliven your cartoons. Here we see a normal head-on, medium viewpoint. While effective enough, it isn't really that exciting.

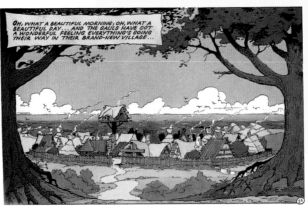

◄ Establishing shots

Here we see a distant establishing viewpoint. Although we can't make out any of the characters, we get a general sense of where the cartoon is set and what kind of atmosphere we can expect.

SEE ALSO

 Focus 66

 Perspective and Foreshortening 68

 Scale 70

◄ Changing angles

Odd angles make for interesting entry points to the image for the reader. This viewpoint is known as a "bird's-eye view" because the reader looks down onto the action. Similarly, the opposite angle, seemingly from the ground looking up, is known as a "worm's-eye view." These angles are used particularly by cartoonists working in comic strips to frame action sequences or even just to make shots of people talking more interesting.

Changing angles means emphasizing how forms look and how light hits them.

Note how the viewpoint emphasizes the relative weights of the characters.

Note how changing the viewpoint forces the cartoonist to think about perspective and foreshortening.

Shadows can help to reinforce the reader's view.

► Using viewpoint to tell a story

Viewpoints within viewpoints are possible, too. Don't think only about where the reader is perceiving the action from—think also about what view of the image they are actually seeing. Are the characters in profile? Three-quarters view (in between head-on and profile)? Are they higher than the reader, or is the reader looking at them from around a corner?

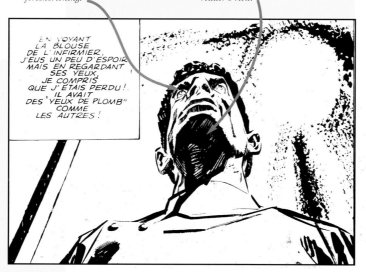

EN VOYANT LA BLOUSE DE L'INFIRMIER, J'EUS UN PEU D'ESPOIR MAIS EN REGARDANT SES YEUX, JE COMPRIS QUE J'ÉTAIS PERDU! IL AVAIT DES "YEUX DE PLOMB" COMME LES AUTRES!

Over to you...

- Viewpoints within viewpoints are possible too. Draw an action cartoon, but don't only think about where the reader is perceiving the action from—think also about what view of the image they are actually seeing. Try drawing the same cartoon from each of the following viewpoints:

 – In profile;

 – Three-quarters view; i.e., in between head-on and profile;

 – Higher than the reader, or as if the reader were looking at them from around a corner.

Changing the readers' viewpoint of the action can make a dull scene really come to life.

FOCUS

Another facet of composition is the focus of the image. By using different methods, such as graphic weight, we can direct the reader to where or on whom we are placing the focus of the cartoon strip or panel. By looking at focus as part of the composition, you can see the benefits that a grasp of these concepts can give to cartoon communication.

First, let's consider why you would want to provide a focus for the reader. Through cartooning, the artist is seeking to impart something to the reader, whether it's an exciting story, factual information, or a joke. Isolating elements in your composition focuses the reader's attention in a particular direction. In this way, you can manipulate the reader to receive only the information you are trying to impart, without being sidetracked by other parts of the drawing.

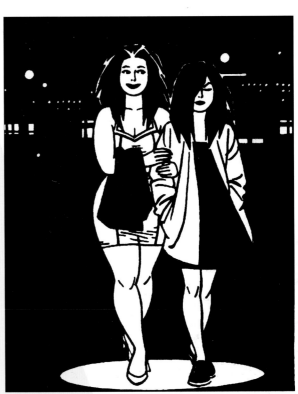

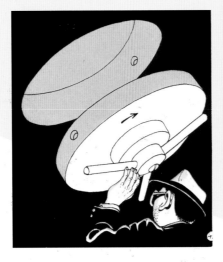

► Color for focus

The use of color is an ideal method of creating focal points in your images. Using either a colored element in an otherwise black and white field of view or a fully rendered colored element amid flat colors will create the focus you need.

▲ Tonal focus

The simplest method of providing focus is the use of flat blacks or areas of tone (such as Letratone or Zipatone—see pages 108–109), or by using computer graphics. With these techniques, we can isolate those characters that are important to the narrative from everything else, or even isolate areas of the scenery in relation to the action. You can even manipulate the light sources in your illustration to help isolate the focused areas.

SEE ALSO
 Graphic Weight **56**

 Tone and Color Principles **100**

Alternative Materials and Composition **108**

Focus is a powerful weapon
in the cartoonist's arsenal.

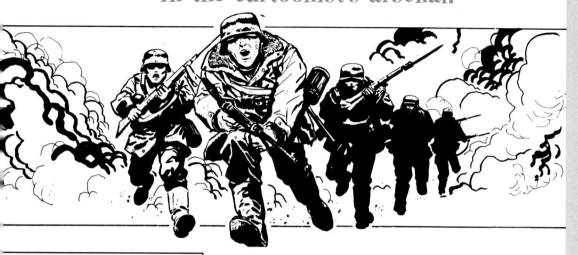

Over to you...

- Look around at different cartoonists' work to see how they selectively use focus to isolate parts of their cartoons.

- How would you use focus to isolate a character in a single panel cartoon, and in a strip cartoon? Would the techniques be very different?

- Can you think of a time when using a limited color palette would help create a sense of focus?

▲ Light and shade

Using tonal differences in contrast, from light to shade, can be very effective. A fully toned character amid flatly drawn ones will immediately focus the reader's eye on that character.

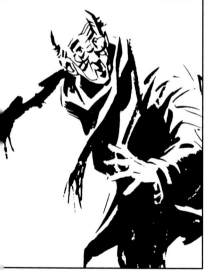

▲ Focus in

Focus in on the elements that you want to highlight to the reader and leave out any extraneous information, such as backgrounds.

THE WRONG FOCUS

Here we can see an image that doesn't make its focus clear. Although the artwork is attractive, the artist has obfuscated the image through over-rendering and a confusing use of the picture plane.

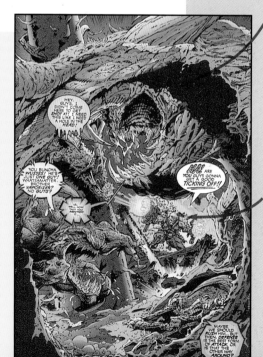

The focus of the image is hard to make out, even though the artist has used a good framing technique. This is an example of over-rendering your image.

A confusing use of the picture plane that distracts from the actual point of the image.

Perspective and Foreshortening

Of all the constituents of composition, perspective is perhaps the most difficult to grasp. But grasp it you should, even if you decide to ignore it completely later on. Perspective and foreshortening are too complex to explain fully in such a small space as this, but the basics are covered to start you on your path of exploration and understanding.

When we look around us, we can see perspective at work everywhere. It is a fact of optics that the farther away objects are, the smaller they seem, but have you also noticed that as objects recede away from us, especially if they are made up of straight lines like a building, they seem to go off to a point in the distance? This point is called the "vanishing point," and is always on the horizon line (see pages 62–63). This point doesn't

really exist of course, but it is an invaluable tool for the artist. By drawing a series of lines radiating out from this point, and placing the straight lines of your object along them, you will create a one-point perspective. If you then imagine another vanishing point on the horizon, and draw another set of lines out from this point that then connect with the lines from the first point, you can construct a two-point perspective, as if you

PERSPECTIVE IN PRACTICE

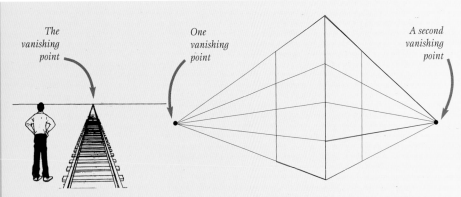

The vanishing point

One vanishing point

A second vanishing point

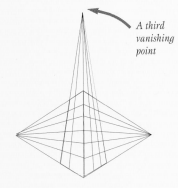

A third vanishing point

Here we can see the most obvious example of a one-point perspective: railroad tracks receding into the distance and the imaginary vanishing point on the horizon.

Two-point perspective exists because we live in a three-dimensional world. By constructing two vanishing points, each one appearing at a different point on the horizon, we can simulate the three-dimensional effect of objects in space on a two-dimensional, or flat, surface.

Three-point perspective takes into account the concepts of up, down, length, and breadth. With three-point perspective we can create the bird's- or worm's-eye views (see pages 64–65), by showing that as well as tapering off into the two-point distance, objects in space also go off to a third point either above (called the "zenith") or below (called the "nadir"), depending on where we are standing when we observe these objects.

SEE ALSO

 Background **62**

Viewpoint **64**

 Working from Observation **74**

Observation to Artwork **76**

were looking at a building on a corner. By then approaching the corner of that building and looking up (or down), you introduce another vanishing point, and create a three-point perspective.

Perspective, overlap (the space where different areas of the picture plane, such as background and foreground, meet), and diminution (the decrease in size of an object as it gets farther away from us) are all examples of "depth cues." These help us to transfer the three-dimensional world in which we live onto two-dimensional media like paper, in order to create a realistic impression of the world in our work. Another depth cue, which is used particularly in relation to drawing living creatures, is called "foreshortening." Foreshortening is an attempt to relate in two dimensions the effect we see in three dimensions when we look at, for example, an arm outstretched toward us. We know that the arm contains the same mass and occupies the same volume of space as it does when it is by the owner's side, but we have to relate that to what we see. As the human form is soft and curved like ovals, it is helpful to imagine the body as a series of circles in perspective, which change shape according to the viewpoint of the reader.

◄ Foreshortening

If we imagine a man made up of ovals, a bit like sausages, then this can help us get a handle on foreshortening. When we look at a sausage head-on or in profile it is quite thin. When we foreshorten it, it appears to be rounder and squatter. The same is true for the human body.

Perspective and foreshortening
techniques allow us to
depict a three-dimensional world on a two-dimensional plane.

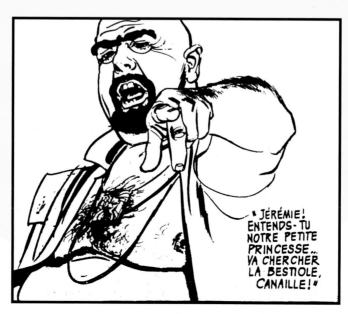

"JÉRÉMIE! ENTENDS-TU NOTRE PETITE PRINCESSE... VA CHERCHER LA BESTIOLE, CANAILLE!"

Over to you...

- Once you understand perspective you can begin to play with it, or even ignore it, for compositional or narrative effect; study cartoonists like Cliff Sterrett and Winsor McCay, who used perspective to create many wonderful impressionistic effects.

- Think of instances when ignoring perspective can heighten the reader's experience.

- Look around you as you go about your daily life to see how perspective and foreshortening occur. Try sketching examples that impress upon you.

◄ People in perspective

This example shows foreshortening at work—to make it feel as if the arm is coming toward the reader, the outstretched limb is drawn rounded and squat as it gets nearer to our viewpoint.

Scale

In the final part of our look at compositional factors, we turn to scale. Scale is basically the relationship between the dimensions of different components of the image, such as the difference in size between a man and a skyscraper.

Scale is based intimately on the shared experiences of the reader and the cartoonist. We both know, for instance, roughly the size of a man. We also know that a skyscraper is much bigger than a man, by a large factor. This is because, in our shared experience, we have seen both men and skyscrapers close up. By using perspective and other compositional devices, such as overlap (where different areas of the picture plane, such as background

and foreground, meet), we can relate those size differences in scale, amplify them, or even negate them in our drawings. By playing with scale in this way we can create special effects that would cost millions on film. Want to show a colony of ants as big as buildings attacking men as they walk the street? Use scale. Want to show a man shrunk to the size of a matchbox? Use scale.

EVOKING A SENSE OF SCALE

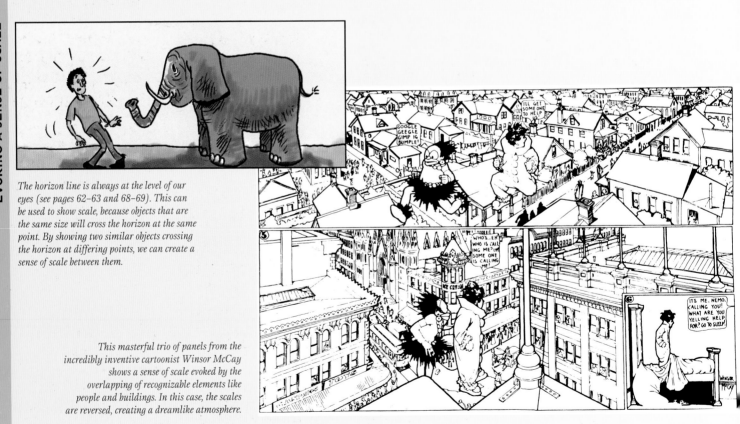

The horizon line is always at the level of our eyes (see pages 62–63 and 68–69). This can be used to show scale, because objects that are the same size will cross the horizon at the same point. By showing two similar objects crossing the horizon at differing points, we can create a sense of scale between them.

This masterful trio of panels from the incredibly inventive cartoonist Winsor McCay shows a sense of scale evoked by the overlapping of recognizable elements like people and buildings. In this case, the scales are reversed, creating a dreamlike atmosphere.

SEE ALSO

 Foreground 58

 Background 62

 Perspective and Foreshortening 68

 Working from Reference 80

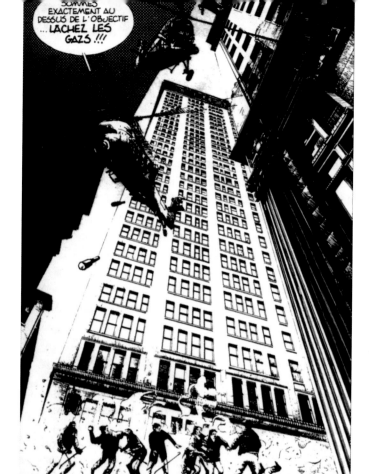

SOMMES EXACTEMENT AU DESSUS DE L'OBJECTIF ...LACHEZ LES GAZS !!!

◄ Awe-inspiring

Here we can see the use of perspective has allowed the artist to create a sense of awe between the size of the onlooker and the building.

Effectively depicting scale

can introduce a sense of "wonder" to your cartoons.

Over to you...

With all that we've seen in the last few sections, how would you:

- Show a street scene from the viewpoint of a man driving in a car approaching an intersection?

- Show a man in the distance being menaced by a giant?

- Draw a goal being scored in a soccer game from the point of view of the goalkeeper? Or from the striker? Or from a fan in the grandstand?

- Use perspective to show a man looking down an empty elevator shaft?

- What would you place in the fore-, mid-, and background to show a couple kissing in the middle of a huge crowd while a carnival is going on?

GOD IS NOT DEAD HE IS MERELY UNEMPLOYED

◄ Scale on its head

This panel by Walt Kelly, from his strip Pogo, *uses the caveman character to illustrate the size of the letters carved into the rock.*

Chapter 4
Over to You—
Cartooning Practice

By now you should have a good idea about **all the separate elements** that make up a **successful cartoon**-from **basic figure work** to **amusing caricatures** and **funny animals,** and from **settings, scale, and perspective** to **lighting, viewpoints, and graphic weight.** In theory, all these elements are easy to practice individually, but in this next chapter we are going to see how they can all be **combined to create really outstanding cartoons.**

Humor and a willingness to laugh at one's self are essential for a good cartoonist!

A CARTOONIST MUST EAT HIS OWN WEIGHT IN OREOS EVERY TWENTY-FOUR HOURS...

...JUST TO STAY ALIVE!

ARRRF AGGRR!

WOOF!

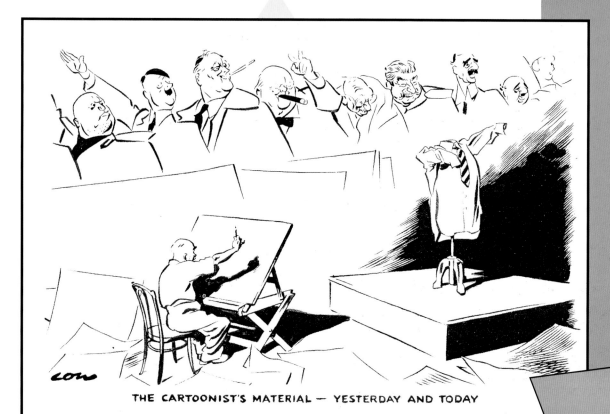

THE CARTOONIST'S MATERIAL — YESTERDAY AND TODAY

We will be looking at **observing the real world** and **obtaining ideas,** both **visually and creatively,** for future reference. Combined with this, we will explain how it is possible to **translate various situations and real-world concepts into a workable cartoon.**

Working from Observation

One of the best ways to fine-tune your cartooning skills is to simply open your eyes and ears and observe the world around you. There are literally thousands of opportunities every day that you can study and learn from.

Get into the habit of carrying a small sketchbook and pen or pencil wherever you go. This means that whenever you see an amusing incident or interesting person, you can capture a rough likeness to use later on. Make time to visit places where large amounts of people gather, such as the park, beach, or railroad station, and sketch the people. These sketches should only take a minute or so, and they will capture the speed and movement necessary for a good cartoon.

Try to eavesdrop on conversations. Very often the best humor comes from everyday situations, and, like a stand-up comedian, the cartoonist can gain a great deal of information by simply observing human interaction.

Remember not to be obtrusive when sketching.

◀ **Sketch book**

Try not to limit yourself to sketching people and buildings; draw plants and animals as well.

▶ **People watching**

Build a database of as many sketches as possible of people walking, sitting, running, and talking together. Look for as many different body types, ethnic mixes, and clothing styles as possible. Remember that there is no such thing as an average human physique! This will give you a sense of how people react in the real world, which will, in turn, improve your composition and figure work.

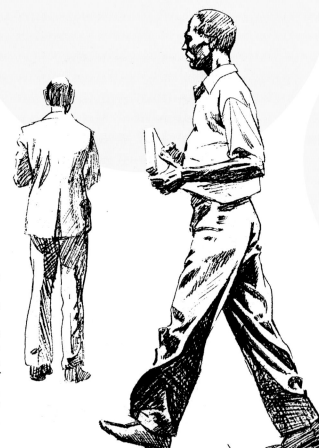

SEE ALSO

 Expressive Figures **36**

 Background **62**

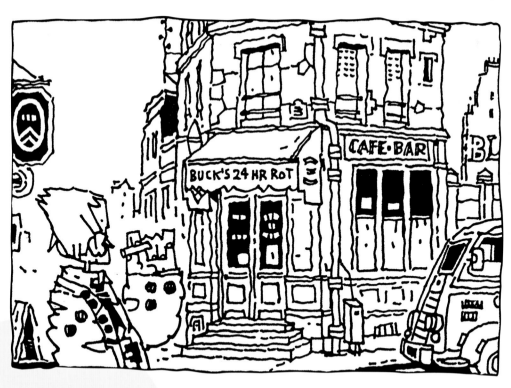

▲ Settings and scenery

Study inanimate objects, such as buildings and automobiles, as well as people. This will help give your backgrounds more credibility.

Over to you...

- Carry a sketchbook and drawing materials around with you, and jot down any amusing or interesting overheard conversations.

- Sketch people, places, automobiles, and animals— in fact, anything you think you will need in your cartoons—at every available opportunity. The more you practice, the quicker you will improve.

▼ Portable sketch kit

Try to carry a sketch kit containing a pencil, paper, and an eraser with you at all times—you'll never know when you might need it!

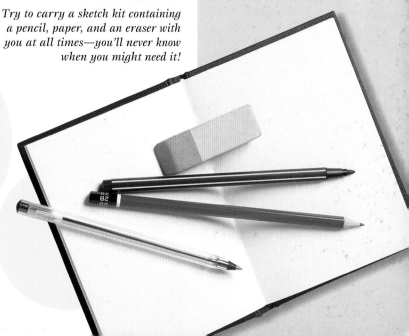

Some people do not like to be drawn, or **will act self-consciously** and differently if they **feel they are being watched.**

Observation to Artwork

Once you have gathered enough material from observation, both written and drawn, it is time to head home and translate that raw data into workable material for a cartoon.

Any basic figure sketches you have made will now need more work to flesh them out and remove any excess lines. This can be done by simply copying a neater version onto the final artwork or, if the sketch is more polished, tracing the original using a light box or tracing paper.

The composition of the new artwork may be comprised of several different observational sketches, so arrange the figures in a rough sketch first; some figures may need reducing if they are in the background, for example. Take elements from different sketches and combine them to create new situations.

This stage of the cartoon process is crucial, as it is where rough ideas come together...

JOKE TELLING

Think about the type of cartoon you are drawing. For comic strips, you will need to plan your pacing and storytelling, as there will be as many as 10 to 15 separate drawings on a single page. Here is the same overheard joke told in two very different ways. On the near right it is told as a one-picture panel with several word balloons, while on the far right it is told in a more traditional newspaper strip. Note the differences in pacing.

Here, both characters' faces are in view, and the reaction of the person asking the question is instantly visible; this gives immediacy to the joke and speeds up the pace of the cartoon.

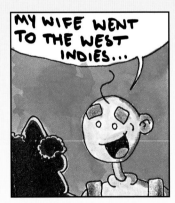

In this telling of the joke, the first panel of the strip starts with a close-up of the joke teller. Note that the reader is peering over the listener's shoulder in the foreground.

SEE ALSO

 Metonymic Distortion **32**

 Cartoon Texts **52**

 Working from Observation **74**

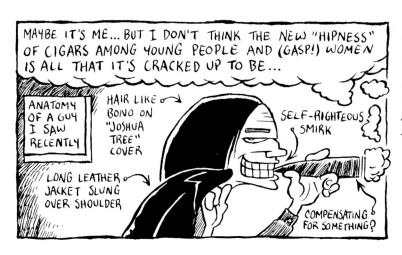

MAYBE IT'S ME... BUT I DON'T THINK THE NEW "HIPNESS" OF CIGARS AMONG YOUNG PEOPLE AND (GASP!) WOMEN IS ALL THAT IT'S CRACKED UP TO BE...

ANATOMY OF A GUY I SAW RECENTLY

HAIR LIKE BONO ON "JOSHUA TREE" COVER

SELF-RIGHTEOUS SMIRK

LONG LEATHER JACKET SLUNG OVER SHOULDER

COMPENSATING FOR SOMETHING?

◀ Character to caricature

Remember to use metonymic distortion, and exaggerate prominent features to give a person drawn from real life a more cartoonlike feel.

...to create the final, polished cartoon.

Over to you...

- Plan out the final cartoon. Choose the format that fits the idea most appropriately. Is it a one-panel gag, a newspaper strip, an editorial cartoon, or even a five-page comic strip?

- Make alterations and additions to your original sketches so that the composition and look work better in the final penciled version.

- Plan whether you will use color or not and how the colors can be used to create the mood of the scene.

- Look again at the joke-telling exercise on this and the facing pages. Can you think of other ways of representing this joke visually?

JAMAICA?

Next, we cut to a reaction shot of the listener; the reader is now observing from the joke teller's point of view.

NO, IT WAS HER DECISION!

Now we return to a repeat of the first panel, but with new facial expressions.

Finally, a silent reaction shot is created, to emphasize the character's facial expressions and therefore add pace and weight to the joke.

Maintaining an Idea Bank

One of the most useful weapons you can have in your cartooning arsenal is an "Idea Bank." This will be your biggest reference point when it comes to creating new cartoons, and for when you get that dreaded writer's or artist's "block."

The majority of your Idea Bank file will be split into two parts, the written ideas file and the graphic ideas file. In the written ideas file you should collect as many ideas for gags, plot lines, and snippets of dialogue as possible. This can come from anywhere. One of the most frequent questions writers get asked is "Where do you get your ideas from?" The answer is, of course, everywhere. Whether it is an overheard conversation, a newspaper report, or something you saw on television that you thought was interesting—cut it out or write it down as something that could possibly be developed into a cartoon.

Similarly a graphic ideas file is built up using pictures from your sketchbook, books, and magazines, or even photographs you have taken yourself. These pictures can be referred back to when drawing tricky or technical pictures, such as automobiles or vacuum cleaners.

Make sure that your **Idea Bank is easily accessible** at all times and **clearly labeled...**

PLANNING AHEAD

The Idea Bank is very good for jotting down sequences for newspaper strips or cartoon books. Plan ahead for the pacing and composition of each strip in small, thumbnail sketches, so when it comes to the final drawing you don't waste time making mistakes or unnecessary changes.

Here, the artist is trying out various positions for the lettering balloons.

Don't be afraid of crossing out mistakes, just write notes in the margins of any corrections.

Take text ideas and turn them into visual representations.

SEE ALSO

The Workspace 16

Working from Observation 74

Working from Reference 80

◄Your essential resource library

Once you have set up an Idea Bank, you will be able to dip into this resource any time you fall short of a concept. It can be an essential crutch when deadlines are looming!

Over to you...

- File your material using a system that works for you. While filing your ideas alphabetically may work for some people, others prefer to file their ideas thematically.

- Try to create a cartoon story from the material in your Idea Bank; but first of all think about who you want to be reading your story—who is your target audience?

- Keep adding to your Idea Bank and refer back to it constantly. There may be something buried in there that you had put aside for one project that might be perfect for another.

...as there is **nothing worse than** searching for that **sketch or reference** article that could be anywhere!

▼Sketch collection

The Idea Bank is an excellent place to store reference drawings and notes on characters you may be using on a regular basis. Try to create several drawings of each character in a variety of poses and with several facial expressions, for future reference.

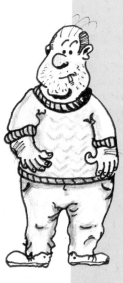

Working from Reference

Apart from direct observation and sketches, the next best source of reference is the variety of images from your "image library." This differs from the Idea Bank, in that it is a reference point for specific images that you will use to remind yourself of how various objects look, rather than as a starting point for an idea.

Perhaps the easiest way to work from reference is simply by flicking through magazines, newspapers, and books, and by looking at photographs. Alternatively, take your own photos of the objects and people you want to reproduce in your own style in your cartoons. Other sources of visuals are your local library or the Internet. Once you have selected the images, file them in a system that suits your purposes, either alphabetically or thematically.

You can **create** **interesting effects** and styles...

PHOTOGRAPHIC REFERENCE

When working from photographs, remember that this is only the start, and don't try to make the final drawing too realistic. Any photograph is worth keeping on file if you feel there could be a potential cartoon character or setting within it.

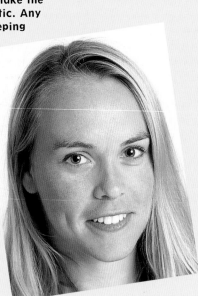

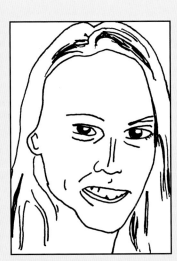

1. The original tracing will be very similar to the actual photograph.

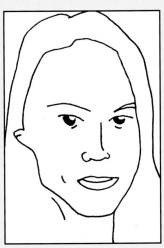

2. Once you have a drawn version of the photograph, start to tidy up the linework.

SEE ALSO

Expressive Faces **34**

Working from Observation **74**

 Maintaining an Idea Bank **78**

 Photocopy Montage **96**

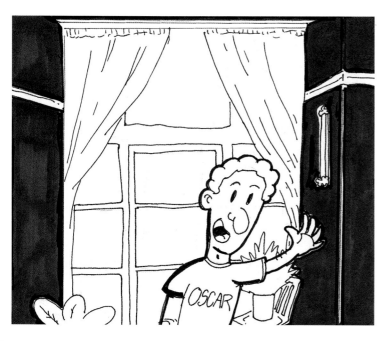

◄ Backgrounds

Here a cartoon figure has been placed in an impressionistic background copied from a photograph. Note how the soft, round figure stands out against the sharp angles of the background.

Over to you...

- Start clipping out images from papers and magazines that you might find useful. For example, if you are doing a series of strips set in the jungle, look for pictures of tropical plants, panthers, snakes, spiders, and other wildlife. This will prove invaluable in the future.

- Catalog your images into accessible, separate sections such as "Figures Running" or "Police Officers."

- Practice drawing by copying from pictures to develop your own cartoon style.

...by **combining copied images** with your **cartoon** designs of **characters.**

3. You will want to keep your own cartoon style, so think about reducing the amount of detail needed in order to make the image flow better.

► Technological help

Images can be directly traced using a lightbox and tracing paper. An alternative way of copying material is by projecting the image onto a drawing surface with an overhead projector.

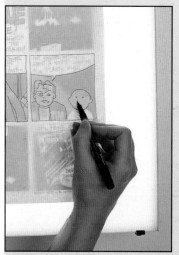

Chapter 5
Materials & Methods
Paper Media

In the following section we will look at the **materials and methods** used to create **cartoons on analog media,** that is, by **non-digital or non-computerized methods.** This mainly refers to the creation of **cartoons on paper using pens, pencils, ink, and paints.**

Many different types of color media can be used on paper to create different effects and feels.

We'll look at how to **pick the best materials** to use **for any particular job,** and how to use and look after those materials to create your best work for years to come.

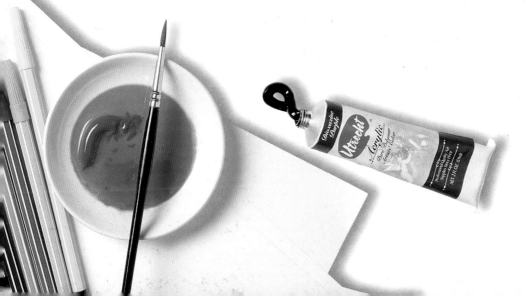

Using a brush creates a fluid line that's pleasing to the eye.

Paper Types

There are several types of paper, and while some cartoonists swear by one type or another, others mix and match depending on the job they are doing.

When starting out, it's best to try a variety of paper types to see just what you can do with them and where their deficiencies may lie. Note also that paper quality varies even within batches of the same type by the same manufacturer. You may think that you've discovered the perfect paper, only to find that it's close to useless the next time you buy it.

Paper is measured by two separate dimensions: size and weight.

The size of the paper is measured either in imperial units, mainly in the United States, or by metric AB measurements. Paper weight, the measure of how stiff and cardlike the paper is, is commonly measured in pounds in the United States, and in grams per square meter (gsm) in the UK and most of Europe.

TYPES OF PAPER

Below are the main types of paper used by cartoonists, along with an outline of their normal uses.

line board

flexible board

Line papers and boards are mainly used for drawing, and have a smooth surface—not much of a tooth. Although these boards are very good for pencil drawing, you may have problems with them if you use a brush to ink. Because they have a smooth surface, the ink doesn't absorb very easily, especially when applied with a brush. A dip pen is a better choice on this type of paper, as the nib actually scratches the surface, allowing the ink to be better absorbed. Erasing can be a problem on this paper, too. If you pencil firmly you will scratch the

line paper

drawn line into the paper, and this cannot be erased. You may also find that ink either smudges or comes off with excessive erasing. That said, line papers and boards are popularly used for line art cartoons because of their robustness and their reasonable price.

Braided boards have a rougher surface than line boards and thus can be painted on with a variety of media. Their surface also makes them ideal to ink on with a brush. They are not much good when working with a dip pen, however, as the surface can cause the pen to snag and splatter the ink. Markers are out, too, particularly those that are solvent based, since the ink can bleed and make a controlled line an impossibility.

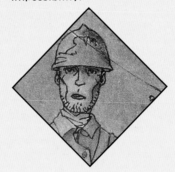
braided board

Flexible boards are the most common type of paper used for cartooning; Bristol board falls into this category. Made from layers of paper, Bristol board is usually heavy enough to count as a board, yet light enough to be economically mailed to a publisher. Bristol board typically comes as two- or three-ply (or layers). It usually has a smooth side and a rougher side, making it ideal for pen or brush. Its ideal weight is 120 lb. (250 gsm), making it heavy enough to take ink (and color) well, but light enough to send through the mail and flexible enough to wrap around the scanning drum at the repro house.

IMPERIAL SIZES	
Imperial	22 x 30 in. (559 x 762 mm)
Half imperial	15 x 22 in. (381 x 559 mm)
Double imperial	30 x 44 in. (762 x 1118 mm)

A SIZES	
A1	23.39 x 33.11 in. (594 x 841 mm)
A2	16.54 x 23.39 in. (420 x 594 mm)
A3	11.69 x 16.54 in. (297 x 420 mm)
A4	8.27 x 11.69 in. (210 x 297 mm)

PAPER WEIGHTS	
72 lb.	150 gsm
90 lb.	180 gsm
120 lb.	240 gsm
140 lb.	285 gsm
200 lb.	410 gsm
300 lb.	600 gsm
400 lb.	850 gsm

Over to you...

- Like all art equipment, you get what you pay for with paper. Try to find the best quality of paper you can, even though it will probably come at a premium.

- Check out your nearest art supply store for paper types. If you ask nicely, they may even let you sample a few.

- It's worth perusing trade magazines to find out what other cartoonists use, and then use that information as a basis for your testing.

- Never stick to one brand of paper, as a single brand can often change in quality from batch to batch. Always be ready to experiment.

Most good paper, whether line or braided, is also available mounted to a hard backing board; this is known as **stiff board**. Mounting the paper makes it ideal for use in presentations, but difficult to send through the mail in any quantity. If you do use stiff boards for a job, and that job is for publication, make sure that the boards are "strippable," meaning the paper surface (with your artwork on it) can be separated from the backing board to enable it to be ripped around the drum of the scanner at the repro house. If this is not done, the repro house may tear the artwork while trying to strip it.

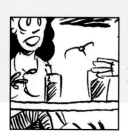
strippable board

tracing paper

layout paper

Layout paper—a thin paper usually used by layout artists in advertising agencies—is ideal for page compositions, ready to be transferred to the actual art board using a lightbox. **Tracing paper** is a thin, translucent paper used mostly for roughing out compositions and fixing mistakes on the original art. Both layout and tracing paper are incredibly useful, but they are not replacements for a good-quality drawing paper.

There are other alternatives to the more expensive art papers and boards. These include **vellum paper**, a rough-surfaced paper available in a range of weights that is good for line and color work; **lining paper**, a lighter paper that is good for sketching but not a lot else; and **bond** or **copy paper**, which are perfectly adequate for single line cartoons and roughs.

vellum paper

Always get the
**right
paper** for the
right job.

Pencils

Pencils are an important part of a cartoonist's tool kit, and one of the most personal. The types of pencils available may seem bewildering at first, but with a little patience and experimentation, choosing a pencil you can be happy with is easy.

◀ Graphite or "lead" pencils

Graphite pencils (the normal "lead" pencils) come in a range of soft and hard grades. The hard pencils are arranged from 6H (the hardest, with more clay than graphite in the lead) to H (the softest of the hard leads). Similarly, the soft pencils are arranged from 6B (the softest) to B. In the middle is the HB, the general-use pencil. The harder pencils produce a sharp but faint line, they don't smear much, and they need less sharpening than softer ones. The softer pencils produce a fuzzier but darker line, smear easily (especially the softest grades), and blunt quickly. Most cartoonists use something between a 2H and a 2B.

▼ Non-repro blue

More and more cartoonists are turning to non-reproducing blue pencils to do their penciling. These have a blue "lead" that makes a mark that isn't picked up by cameras used in some reproduction processes or by photocopiers. They eliminate the need to erase, saving time and effort. A disadvantage, however, is that some of these pencils are quite waxy, making them both hard to erase if a mistake is made, and difficult to ink over. Trial and error will allow you to find the non-repro pencil that is to your liking. Make sure that the pencil is marked as "non-repro" or "non-photo"; a normal blue coloring pencil won't work.

The last pencil in the graphite range is the "F" pencil. This is equivalent to an HB pencil, but with the added benefit of being soluble in water, making it ideal for under-penciling a watercolor painting.

MIXING PENCILS

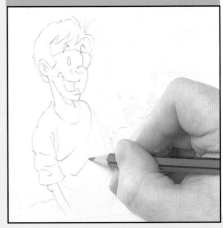

Some cartoonists rough out their compositions using a non-repro blue pencil and then go over them with normal graphite pencils. Whatever you use to make your roughs, always try to pencil as lightly as you can so that if you make a mistake you can correct it easily. Try not to dig the lead into the paper too much to avoid making marks that are hard to remove and that can be picked up via the repro process.

Penciling is fun, but erasing pencils marks after inking can be a chore.

SEE ALSO
Erasers and Erasing Techniques 98

 Blue Lines 106

 Reprographics 148

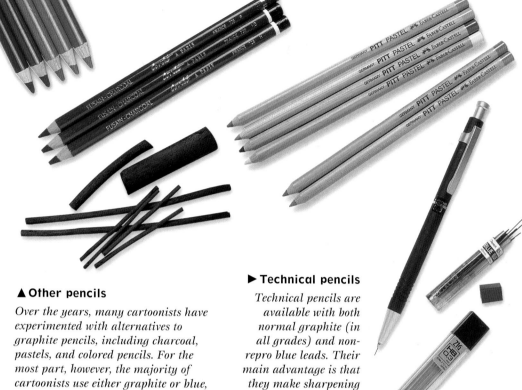

▲ Other pencils

Over the years, many cartoonists have experimented with alternatives to graphite pencils, including charcoal, pastels, and colored pencils. For the most part, however, the majority of cartoonists use either graphite or blue, non-repro leads.

▶ Technical pencils

Technical pencils are available with both normal graphite (in all grades) and non-repro blue leads. Their main advantage is that they make sharpening a thing of the past.

Over to you...

- Get a good range of pencils, plus some charcoal, and experiment with the kind of marks you can make. How would you go about inking some of those marks?

- Non-repro blue pencils are used more and more often. Try offsetting your normal pencils with underdrawing using a non-repro blue pencil.

- Try not to pencil too hard. To see what happens when you do, pencil something with great force, erase it and photocopy the paper. What do you see?

PENCIL LINES

Pencils come in many types, and it's good to know the different types of mark that each type creates. With this knowledge, you can make sure that you pick the right pencil for the job.

A 2B pencil is a nice general pencil that gives a thick, dark line.

For a more "thick-and-thin" look, try using a pencil that isn't round, but has a rectangular tip—a flattened pencil. You can get these from art and hardware stores.

A water-soluble pastel or F pencil can be used to add washes.

Charcoal is more of a specialty pencil; it is dark and shows through the texture of the paper.

Non-repro blue is the lazy cartoonist's choice! There is no erasing with this blue as it doesn't reproduce mechanically.

Try to **use a non-repro blue pencil** if erasing makes you miserable.

Inks

The act of inking a cartoon—tracing over pencil lines with ink, adding line weight and shading—comes from the necessity of making a cartoon ready for print. In these days of high-resolution scanning, this is perhaps not as necessary as it once was, but it is often in the inking stage that the cartoonist can really bring his or her work to life. But which inks give the best effects? Is normal fountain pen ink good enough?

Unless you are using ink to create a wash, the ink you use should be waterproof and lightfast so that it will not run if water is splashed over it, or fade if left in normal lighting levels. For the most part that means India ink, a dense, black ink. India ink is ideal for cartoonists because it remains black over large areas and can be used in a variety of implements—brushes, pens, etc.

There are many brands of India ink, but the most widely used are made by Higgins, Pelikan, Rotring, and Winsor & Newton. All of these inks are good, but make sure you buy the waterproof India variety.

It is important to think about where you place your ink bottles in your workspace. If you work on a slanted drawing board, it is unwise to secure the ink to the board (especially if you're clumsy). Instead, set up a small table next to your board on the same side as your drawing hand.

◄ ▼ Keeping ink usable

India ink is made by suspending pigment particles in a liquid medium, so it is prone to clumping and settling. To stop this from happening, shake the ink bottle thoroughly before use every time. If the ink has not been used for a while, or if you've left the cap off for a long time, then try mixing the ink with a straw or a similar implement to move the sediment around. You can also thin the ink by adding a few drops of ammonia or distilled water.

Ink is a matter of **personal choice,** but most cartoonists prefer **an ink that's really black.**

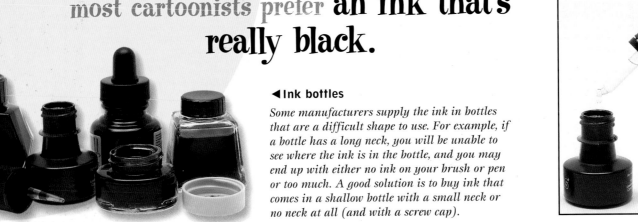

◄ Ink bottles

Some manufacturers supply the ink in bottles that are a difficult shape to use. For example, if a bottle has a long neck, you will be unable to see where the ink is in the bottle, and you may end up with either no ink on your brush or pen or too much. A good solution is to buy ink that comes in a shallow bottle with a small neck or no neck at all (and with a screw cap).

SEE ALSO

The Workspace 16

Choosing Equipment 20

Pens and Markers 90

MIXING A WASH

To create an ink wash (a gray liquid that you can use to add areas of tone), you need to dilute the ink. The usual mixture is one part ink to two parts water, although this really depends on how dark you want the wash. A little trial and error will pay off here. Of course, waterproof ink won't mix with water easily. Use water-soluble ink, such as the type used for calligraphy.

FIXING AN ARTWORK

Fix any inked artwork with a fixative or hair spray when dry, to protect it from water splashes.

Over to you...

- Get a few different types of India ink to try out. Don't mix them together though, as different manufacturers use different formulations.

- Try out different brushes with ink to see the variety of effects that can be made. Remember not to use the same brushes for inking as you do for color; the ink particles that get left on the brush (even after a thorough cleaning) can sometimes come loose and mix with the colors.

Higgins Black Magic
is an ink widely used by cartoonists.

BRUSH AND NIB CARE

Never forget to clean your brushes. India ink is a killer for brushes, and it can also lessen the life span of nibs.

When cleaning your brushes, make sure that you use cool water (hot water can loosen the glue that holds the hairs of the brush into the barrel or ferrule) and a mild soap. Clean right down to the base of the brush, and then use a tissue to get rid of excess water.

Always move the tissue in the direction of the bristles. When you are done cleaning, the brush should come to a point. If it doesn't, place it in your mouth and pull it out through puckered lips.

Store brushes with the bristles facing up, and cover them with the protector that you get when you buy the brush.

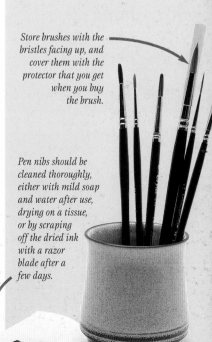

Pen nibs should be cleaned thoroughly, either with mild soap and water after use, drying on a tissue, or by scraping off the dried ink with a razor blade after a few days.

Pens and Markers

If you decide to use a pen or a marker to do your inking, you should be aware of the different effects that each type of pen will create. Sticking to one type of pen might suit you best, or a mix-and-match approach may be better suited to your way of working. Pens are more rigid than brushes, but with practice, you can make lines with a pen that are just as varied and aesthetically pleasing as those made with any brush.

Keep your pen points clean, as this will help you to get extra use from them.

PEN EFFECTS

Many cartoonists use a **dip pen** and steel pen points to ink, the advantage being the ability to create variable widths of line with the same point. Using dip pens requires a great deal of patience and practice, but there are a few things you can do from the start to help you on your way. When you first use a pen point, either immerse it in boiling water for a few seconds or hold it briefly over a lit match. This will remove the sealing ink from the point and make it much easier to work with. When you ink, always pull the point toward you; never push it. Always do a test line after dipping the pen in the ink, and shake off any drips or blobs. Finally, always check for paper fibers in the point of the pen after every line, and wipe off excess ink before redipping.

Even a normal **fountain pen** can be useful in cartooning. The nib will give some flexibility, and as long as you use fountain pen ink and not India ink, the pen will be easy to use and clean without clogging. Some panel cartoonists use fountain pens for everything, whereas others use them for lettering alone. Cartoonists famed for their use of a fountain pen are the American cartoonist Jules Feiffer and the late British cartoonist Mel Calman.

The **technical pen,** or stylograph, the best known of which is the Rapidograph or isograph, features a point made from a thin steel tube set to a precise width. Down the barrel of this point is a weighted piece of thin wire that keeps the ink from leaking when the point is not touching paper or film. Originally used by draftsmen and architects, technical pens are used by cartoonists for ruling lines and panel borders, while others use them for inking almost everything. Care should be taken when using these pens as they will clog very easily with India ink. They should be cleaned often and the ink changed regularly. Also note that they won't produce variable line widths unless you redraw over the lines.

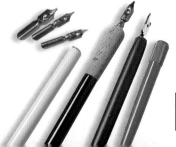

▶ Dip pens

There are many manufacturers of pen points, but the most commonly used by cartoonists are those made by Hunt or Gillott. Points can be divided into a number of categories (see right).

Reservoir points have a built-in ink reservoir, allowing them to be used for longer stretches between dipping. They usually have rounded or square ends, and are often used for lettering. The best and most widely used examples of this type of point are the Speedball points made by Hunt.

Mapping points are the normal, large points, used for everyday inking. They, too, are flexible, but they often take longer to "work in" than a crowquill. The Gillott 170 and 290 are excellent examples of this type of point.

Crowquills are the smallest type of points, and need a special holder to fit them. Cartoonists who use these often prefer the Hunt 102 point, as it is flexible and longlasting if used correctly.

Markers are increasingly used by cartoonists because of their ease of use and flexibility. You can buy markers with a variety of point sizes and shapes, from round to flat, and with a variety of formulations of ink. Trial and error will help you to find the markers you like, but beware: marker ink often fades in sunlight, turning brown or purple. Markers can also smudge, and may turn out to be a more expensive option than a good set of brushes or pen points. Always test them in the store before buying by drawing a line and then rubbing your thumb over the line. Be careful when using solvent-based markers in a confined space, as the fumes are toxic.

A fairly recent innovation is the **brush pen**. This is a disposable pen, with or without ink refills, with a point like a brush made from nylon bristles. Using these pens is an excellent way of getting to know how to use a brush without all the tedious dipping and cleaning. The fact that they are cheaper than a real sable brush also means that they are good for experimentation and sketching. They do wear out, however, with the point of the brush becoming flattened and worn, and they will turn out to be expensive in the long run if used for more than just sketching.

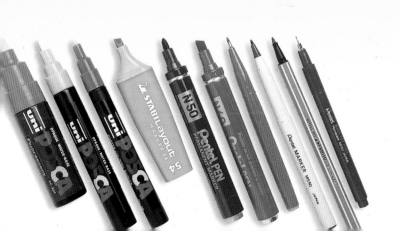

Over to you...

- Pen points and nibs aren't always reliable. Be aware that perhaps one in every five points that you buy won't be any good. If your art supply store will allow you to, check them carefully before buying.

- Markers can fade in sunlight, so store them carefully.

- Solvent-based markers last longer than water-based markers, and are, therefore, a better investment.

- Always make a few test lines with a pen point after dipping it in ink to stop blobs and splatters.

- Keep a rag handy for wiping off excess ink from pen points; it will also be useful for cleaning up spills. Don't use paper towels, as they will leave fibers on the prongs of the pen point.

Hatching and Stippling

Hatching and stippling are two valuable methods of creating tone in your cartoons. They are important techniques to learn and use properly right from the outset. The most important thing to learn about hatching and stippling is that every mark you make should mean something. That is, every line you put down should be there for a reason, not just because it looks pretty or fills up space.

▶ **Contours**

Making cross-hatching follow the contours of your line art can be a very effective method of showing shadows, muscle tone, and folds in clothing.

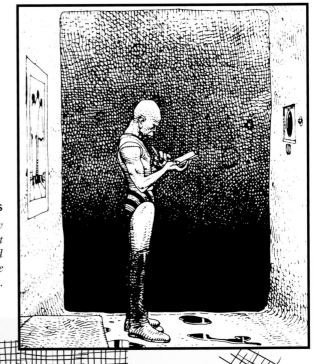

HATCHING

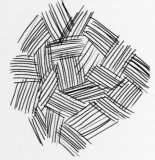

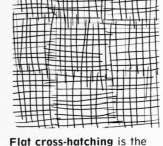

The most basic type of hatching is **flat hatching**. This is where the pen makes parallel strokes in one direction only. This type of hatching is useful for showing one tonal difference only.

Next, there's **directional hatching**. Again, it's made up of parallel strokes, but this time the direction changes between each set of strokes. Care should be taken, as with all hatching, that the lines are made definitely, and not with a scribbling motion.

Flat cross-hatching is the next step up. Two sets of hatched lines, one perpendicular to the other, are placed on top of each other. When used with flat hatching, this method can be very evocative of tonal ranges.

Directional cross-hatching is like flat cross-hatching, but it is made up of more hatching layers than just two, and in other directions than just at right angles, making it useful for depicting tones close to black.

SEE ALSO

 Background 62

 Working from Reference 80

 Pens and Markers 90

STIPPLING

Stippling is different from hatching in that it is made with strokes of the pen or brush that are more akin to dots than actual lines. That said, stippling is often made up of lines, just very short ones.

Loose stippling is a useful, free way of approximating tone. Made up of irregular-sized strokes and dots, loose stippling nevertheless requires a degree of care and control to avoid making the effect look like nothing more than random splotches.

Tight stippling is like the pointillism technique first introduced in the nineteenth century by French artist Georges Seurat, where a tightly arranged grouping of dots depicted tonal ranges and shading. Today, the foremost user of this technique is the American cartoonist Drew Freidman, who painstakingly creates his cartoons with many dots.

Over to you...

- Practice hatching frequently. The more you do it, the better you'll get.

- Look at how other cartoonists use hatching. Try to imitate them.

- Practice hatching with all sorts of pens.

- Try stippling with different-colored markers in order to build up a contoured surface and tonal differences.

- Try combining hatching and stippling techniques, perhaps using hatching for figures and stippling for backgrounds.

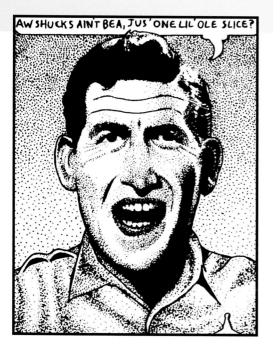

◄ Stippling in action

A good use of stippling, illustrated by the work of Drew Freidman, is the following of photographic or painted tonal reference with just pen and ink. If used well, this technique can be staggeringly close to the original and can be very lifelike.

Use **hatching or stippling** to **give** your drawing **tonal value.**

Brush Rendering

There is a reason why most of the greatest cartoonists have used a brush to render their cartoons in ink; it is the most versatile tool that the cartoonist has. Equally good at creating fine lines as it is at creating large areas of flat black, the brush, when used by someone who is comfortable with its intricacies, is unequaled at making the cartoonist's work really come to life.

Many cartoonists shun the brush, especially when they are starting out, because it isn't as easy to use as a pen. In fact, to become adept with a brush takes a lot of practice and patience. Like pens, brushes come in a variety of sizes and types. Most cartoonists use the sable hair variety of brush, with a significant number using nylon hair brushes. Sable hair brushes are intended for use with watercolor and oil pigments, but are equally good with inks. They are more expensive than nylon, but if taken care of properly, they will last a long time (for brush care see Inks, pages 88-89). Nylon brushes are good, but really are secondary to sable, as they are not as good at creating the variety of lines at which sable brushes excel.

BRUSHSTROKES

Here we can see the types of lines made by sable brushes of different sizes. The most commonly used size by cartoonists is the No. 2, which, at first glance, looks a bit too big. But as we see here, the range of lines the No. 2 makes is quite amazing.

Inking in large areas of black and shadow areas requires concentration and a nice large brush. Don't worry if your blacks aren't homogeneously black right across the solid area of ink, as the repro process will make up for this. Try not to erase over areas of solid black, though, otherwise you may find your blacks becoming brown.

Another technique that can be very evocative in adding tonal values to your cartoons is the so-called "drybrush" technique. This is done by dipping your brush into ink, and then wiping the ink off until the brush is nearly bereft of ink. You then use your brush to add the strokes.

Brush rendering can really add a sense of form and life to your drawings

▶ Mort Gerberg

Some cartoonists only use brushes to fill large areas with black or color. If you are willing to take the risk and practice with a brush, however, you'll find that it is an ideal tool for line work. That said, using a brush isn't easy. It's best to hold the brush almost perpendicular to the paper, and to use your hand to control how much of the point comes into contact with the paper (thereby making the thick and thin line variation we see here). Try to pull rather than push the brush, and move the paper around to ink it.

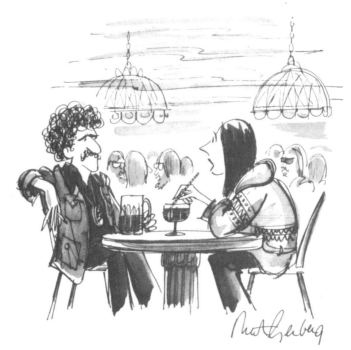

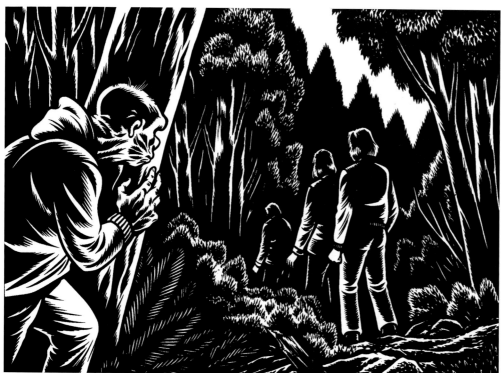

Over to you...

- Practice inking with a brush. You might like to use a brush pen while you are learning as these are relatively inexpensive compared to sable brushes.

- Always pull the brush along the paper, never push.

- Keep old brushes to create interesting effects, and for dry brush techniques.

- Test the brush before buying by dipping the point in water and flicking it to create a point. If the brush point is split, don't buy it.

- When using the brush, make free use of your wrist to create strokes. Don't tighten up by gripping the brush too hard.

◀ Feathering

One of the strengths of using a brush is that it can create areas of tonal difference by a technique called "feathering." This is roughly equivalent to hatching with a pen, but gains its name from the rather distinctive thick to thin lines you get with a brush. Like hatching, feathering is ideal for showing the contours in an object and, with care, can be extremely effective at portraying the consequence of different light sources.

Photocopy Montage

Photocopy montage is one of the more unusual and less used techniques. It can, however, be especially effective when dealing with topical subjects, or to create a range of effects.

The images for a photocopy montage can come from a variety of sources. Simply by cutting out a cartoon image you have drawn, and placing it on a clear photocopy of a photographic landscape, you instantly make the character stand out, giving the appearance of isolation from the environment.

You can also create interesting effects using a photocopier. Try placing an image on the scanner and moving it as the machine takes a scan. Moving the image in different directions will create different effects, for example moving the image in the same direction as the scanner light will create stretched or elongated copies.

Think of what your **cartoon's subject** is...

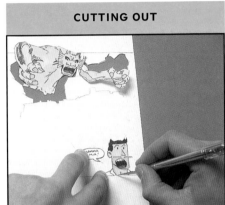

CUTTING OUT

1. Simply cut out a cartoon image you have drawn.

▲ **Creative clippings**

Rearranging old photographs can create new "cartoons" by forming a whole new image.

▶ **Montage mug**

Using a photocopier and mug shots of a person, such as this picture of Carl Flint, you can even create caricatures.

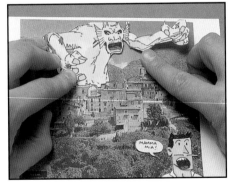

2. Now place it onto a clear photocopy of a photographic landscape. This will instantly make the character stand out, giving the appearance of isolation from the environment.

SEE ALSO

 Foreground **58**

 Background **62**

 Maintaining an Idea Bank **78**

 Scanning **114**

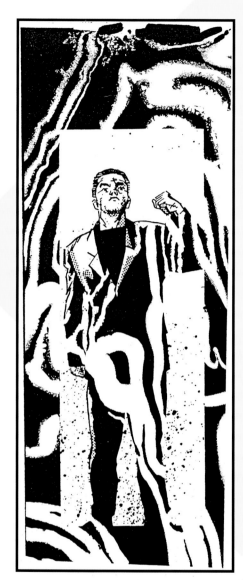

◄ Special effects

You can create a variety of patterns using a photocopier, and then use them as backgrounds.

▲ Imposing images

Simply by cutting out a cartoon image you have drawn and placing it onto a clear photocopy of a photographic landscape, you can instantly make the character stand out.

Over to you...

- Always plan your cartoon montages before gluing.

- Keep rearranging the images until you are happy with the composition.

- Pick images that suit your subject and your style of artwork.

- Remember that you don't have to use photographs or other sources for your montages—you can gather together images you have drawn yourself to use in a montage.

The clouds have been taken from one source.

The man and bridge have been drawn by the artist.

The man in the foreground has been taken from another source to give balance to the picture.

...and then search for **visuals that will match your themes.**

► Layered pictures

This illustration shows how three separate elements can be combined to make a new image.

Erasers and Erasing Techniques

No matter how careful you may be, accidents invariably happen, but that jogged line or spilled bottle of ink doesn't necessarily mean that you have to throw your cartoon away and start again. There are a wide range of erasers that can be used not only to remove mistakes but also to create interesting effects.

Most mistakes can be avoided through careful preparation, such as completing detailed pencil sketches before beginning the inking stage, but there is always a margin for error. Common problems can result in attempted layout changes during inking: the composition may no longer work, additional line work may seem unnecessary once inked, and liquid may spill onto the artwork.

There is a range of erasing and cleaning fluids available that can be used to lift the ink off the page, most notably correction fluid. However, this can be difficult to use and takes practice to master, because too much will stain artwork permanently.

An easier method of erasing is by using a substance called process white, or white opaquing fluid. This is a thick, paint-like liquid that can be painted over black lines so that they no longer appear when the artwork is scanned. Once dried, the process white can be easily drawn over, as long as it has been applied sparingly. If color is being used, opaque paints such as acrylic can be used in this way.

PATCHING IN

Ink can be taken off the page by simply scratching it off, using a mat knife or utility knife. However, this method can be tricky, because the artboard will sometimes become rough, and ink will bleed if redrawn on these areas. Therefore, this method should only be attempted if you are using an artboard such as CS10 or Bristol board. One simple way to correct a mistake is to paste a patch on. This works particularly well if a large area of the artwork is damaged.

Cut out a **patch** of paper to suit the size and shape needed to cover the mistake. Use an aerosol adhesive (in a well-ventilated area) or glue to secure the patch over the artwork. If you are working in black and white, a patch can be as simple as a white **sticker** placed over the artwork.

You can also use **process white** to delete unwanted areas of line. Always remember to go around the edges with the process white as well, so that they don't show in reproduction.

When working in color, it is better to repaint the area separately, exactly to size, of course, **cut** it out, and **paste** it over the damaged artwork.

SEE ALSO

 The Workspace 16

 Paper Types 84

 Inks 88

 Opaque Pigment: Gouaches and Acrylics 104

Making mistakes is only human—even the best cartoonists are fallible.

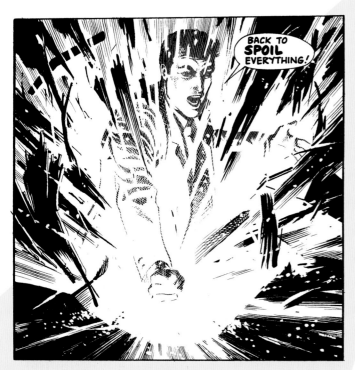

BACK TO SPOIL EVERYTHING!

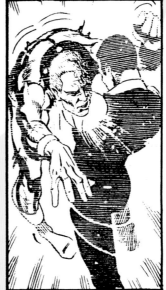

◀▲ No mistake

Process white can be used to good effect when painted over areas of black, and is particularly good for drawing small details. The white lines over this figure drop it into the background and add dramatic effect. You can also dilute process white with water and use it as white ink in a ruling pen.

The trick is to save the picture with a minimum of fuss and extra damage.

There are a variety of erasers for different media—use a putty eraser on charcoal, regular erasers with pencils, and hard abrasive erasers for ink errors.

▶ Useful tools

There is a wide range of erasers and other materials available that you can use to correct mistakes or to create interesting effects.

Over to you...

- Take time to experiment with various techniques, and find out which one is the easiest for you and most suitable for the job.

- Don't be afraid of making mistakes or cleaning them up. Remember that nearly all damaged work can be salvaged.

Aerosol sprays are good for fixing large patches.

Process white is the cartoonist's true friend and can be used to create art as well as hide mistakes.

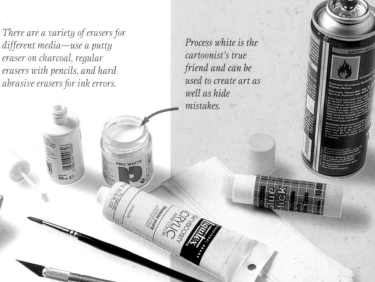

Tone and Color Principles

Color can add a whole new dimension to your cartoons, highlighting emotions, settings, and moods. It can also be used to highlight aspects of an image, and if used correctly it can enhance your work—and earnings, as you tend to get paid more for color work!

COLORING IN

In general, colors can be broken down into three areas: warm, cool, and neutral.

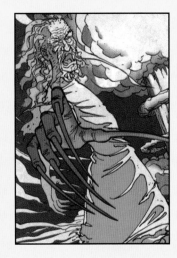

Reds, oranges, and yellows are all **warm colors**. They help express emotions such as anger or embarrassment, and they can create warmth in a picture, such as a cozy fireside light.

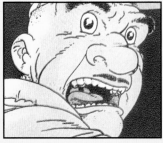

Then there are **neutral colors**, such as purple, that work equally well with both warm and cool colors.

The **cool colors** are white, greens, and blues. These are often used to create negative feelings such as envy, illness, or fear.

◄ One color does it all

Warm colors are used to push aspects of a picture to the front, while using cool colors has the opposite effect. The same effect can be created by varying the amount of saturation of color. A dark saturated tone brings the figures to the foreground, while lighter tones push figures to the background. However, these rules can be broken, as illustrated here, with a limited palette of sepia. Here the lighter characters are brought to the foreground, while the darker room is pushed back.

SEE ALSO Expressive Faces 34 Graphic Weight 56 Foreground 58 Background 62

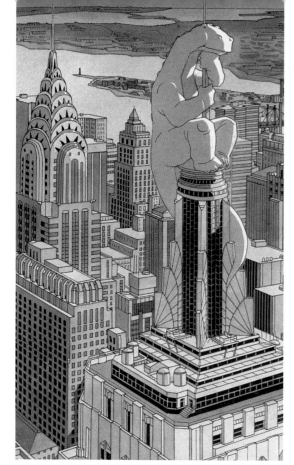

◄ New York dawn

This illustration by Daniel Torres highlights what is possible with a limited palette of orange, purple, and various shades of blue. The warm orange color highlights the central figure and brings it into the foreground, while the cooler blue sets the buildings into the background.

Think about colors before you start.

Over to you...

- Work with a limited palette of one or two colors, and practice different hues and saturations to see how you can build up various effects.

- When planning your artwork, think about the mood and setting, and try out some color roughs before starting the final artwork. Think about the colors before you start. What mood are you trying to create? What colors are you going to use?

- What areas of the cartoon do you want to highlight? Use light, warm colors to do this.

- Draw a variety of expressive faces and color them in according to their moods— for example, use shades of blue for sadness. Now reverse the colors. What effect does this have?

COMBINING COLORS

Colors can also be divided into colors that complement each other, such as blue and green (two cool colors together) or red and yellow (two warm colors together), and colors that contrast, such as red and blue, or green and orange (mixing warm and cool colors).

Colors that complement are better for creating moods such as a dark forest or flashback sequences for passages of time.

Colors that contrast when combined tend to be bright, flat, and garish, and make a picture leap off the page.

What mood are you trying to create?

Transparent Pigment:
Inks and Watercolors

Creating color cartoons can be quite simple, and you don't need to be an expert oil painter to do it. In fact, one of the quickest and easiest ways to add color to a drawing is by using transparent inks or watercolors.

1. Use strips of gummed brown paper or masking tape on thick paper to secure the artwork to the board before coloring.

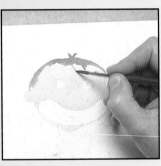

2. Add the colors to the pencil drawing, working from light to dark and allowing each color to dry completely before the next is applied.

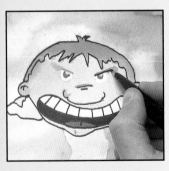

3. Allow all the colors to dry thoroughly before starting on the inking as the final stage.

Before starting to color with inks and watercolors, it is always a good idea to secure your artwork to a drawing board with gummed paper. As you add more liquid to the page, particularly in large amounts, the paper will try to wrinkle and ripple, but securing the artwork will help prevent this, and will stretch the artwork out flat again once dry.

The advantage of using transparent pigmentation is that once the initial drawing is completed, the cartoon can simply be "colored in." However, note that unless you are using waterproof ink that has fully dried, always add the color before the inking stage to avoid smudging or bleeding of the linework.

When working with inks or watercolors, work from light to dark, and leave the brightest highlights of the cartoon as white paper—once this has been colored in, it is very difficult to remove. As you progress, you can darken the artwork where necessary. Remember to go slowly and plan each stage ahead, and be confident.

Colored inks and watercolors are **water-soluble, so you can reduce the saturation** of each color by simply **adding more water.**

SEE ALSO
 Tone and Color Principles **100**

 Opaque Pigment: Gouaches and Acrylics **104**

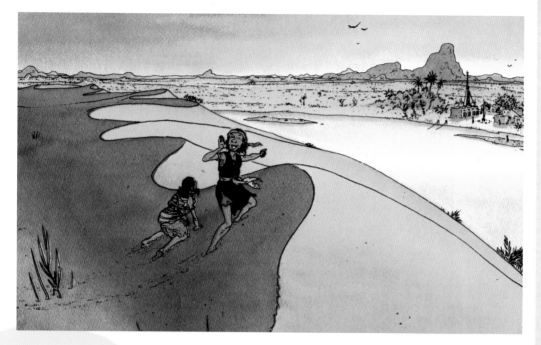

▲ Lush landscape

Ready-mixed inks tend to give a flatter, more single-toned color than traditional watercolors. However, both materials can be mixed to create a variety of color qualities. This picture has been created using ready-mixed inks.

Over to you...

- Experiment with both inks and watercolors. What kinds of effects and moods can you create?

- Plan ahead with your use of materials. Is the picture more suited to a subtle watercolor, or would a stronger acrylic paint effect work better?

- Test your mixed colors on a scrap piece of paper to make sure the color looks right before adding it to the final art. Remember, you will not be able to paint over watercolors effectively.

▼ Take your pick

Watercolors are available in several forms, including solid blocks, water-soluble pencils, and tubes of paint similar to gouache.

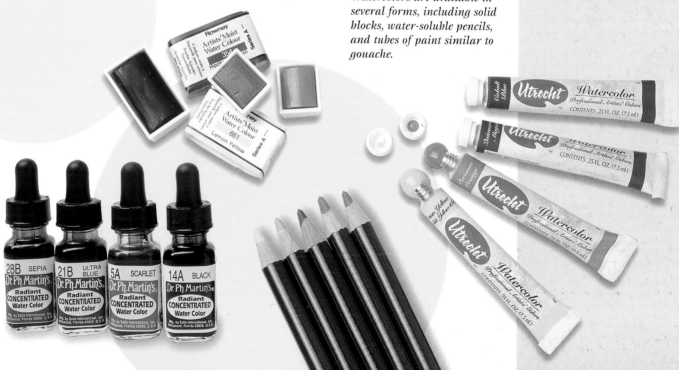

Opaque Pigment:
Gouaches and Acrylics

For a controlled, flat color, gouaches and acrylics are better suited than watercolors or inks. They give a heavier, more solid feel to artwork, and are often used without any black ink lines. In addition, they are very versatile, and can be used in other ways.

Gouaches and acrylics are bought in tubes. They are then mixed with a little water to create a smooth, flat, opaque color that is applied to the cartoon. At first the mixing may prove difficult. Adding too much water will make the paint too thin and transparent and act more like watercolor. Too little water will mean that the paint is lumpy, and this will show up when the work is shot for reproduction. However, a little practice should soon have you mixing up a smooth paste. Alternatively, you can buy ready-made acrylics, but they are more expensive.

Mistakes are easier to correct with acrylics and gouaches...

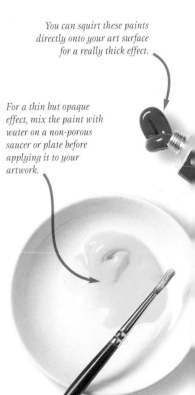

You can squirt these paints directly onto your art surface for a really thick effect.

For a thin but opaque effect, mix the paint with water on a non-porous saucer or plate before applying it to your artwork.

DARK TO LIGHT

Acrylics and gouaches work the opposite way to watercolors, in that the process is one of working from dark to light.

1. First, lay down a medium or tonal ground that will give the balance for the cartoon.

2. When the first layer has dried, add the shadows with darker hues based on the tonal balance.

3. When using gouache and acrylics, the highlights are the last features to be painted or drawn on.

SEE ALSO

 Tone and Color Principles 100

 Transparent Pigment: Inks and Watercolors 102

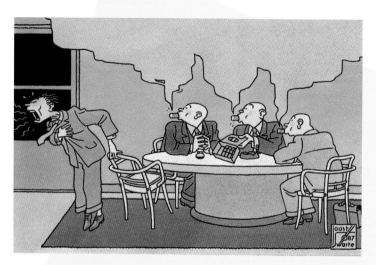

◄ Gasping gray smoke

Think about the color balance in your picture and how flat color can be used for effect. Thinned acrylics can also be drawn over with black lines once they have dried.

Over to you...

- Mix your paints on a non-porous surface, such as an old white plate or mixing palette.

- Practice mixing flat acrylics and gouaches until you manage to get a smooth paint with no streaks.

- Mix larger quantities of the color than you think you'll need. If you run out, you will find it very difficult to mix the exact same color again.

- Prevent your mixed paint from drying by keeping it in a plastic bag or an airtight container.

...because they can be
painted over once dry.

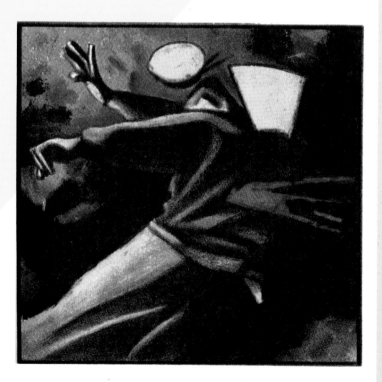

◄ Impacting abstraction

Other opaque pigments that can be used to good effect are pastels, as used here by Lorenzo Mattotti in his cartoon book Fires. Note how the abstract, saturated colors give a strong mood setting.

Blue Lines

One difference between American and European comics is the traditional method of coloring. In the US, up until the 1980s (when computer coloring came into play), colors were selected from a palette and marked up onto photostats of the original pages. Technicians would reproduce these colors using hand separation. In Europe in the 1950s, a technique was developed that allowed for a greater color range and bypassed tedious hand separations: blue lines. Blue lines are still used today in both the U.S. and Europe, although computer coloring is becoming increasingly common.

Developed by Vittorio Leonardo, a color artist for the Belgian publisher Dupuis, blue lines are created by making two high-quality copies of the original artwork—one copy on clear acetate with the line art in black, and the other on good-quality vellum paper with the line art in a nonreproducing blue. The two copies have registration marks applied to them (to enable correct lining up or registration of the art on the two copies), and are then given to the colorist (often the same artist who drew the line art). Using a variety of media, the colorist then colors the blue-line copy of the artwork. Once the colorist is finished, and the art is checked by overlaying the black line art over the top of the colored art, both copies are sent to the repro house.

BLUE-LINE COLORING

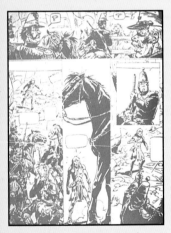

Here we can see the two copies of the artwork; the blue-line copy for coloring, and the black-line version on acetate.

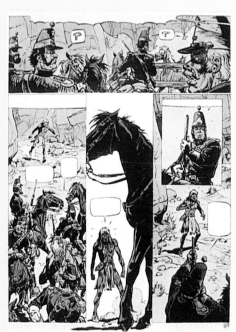

The colorist colors onto the blue-line version of the artwork using a wide variety of media: watercolor, colored dyes, gouache, egg tempera, and acrylics.

SEE ALSO

 Tone and Color Principles **100**

 Alternative Materials and Composition **108**

 Reprographics **148**

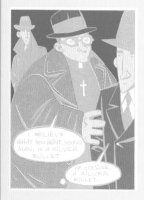

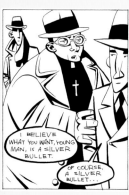

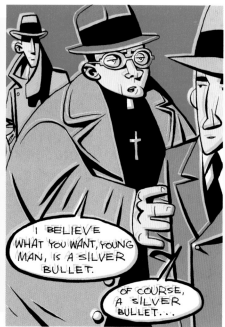

Here we see an example of what happens if the printer doesn't get the registration (or lining up) of the colored artwork and the line art overlay right. A nasty mess!

Over to you...

- You can make your own blue lines using a good photocopier, decent paper, and acetate overlay sheets, which you can get from art supply shops. These will be good enough to practice on, but they aren't sufficient for professional purposes.

- Most good printers will be able to make blue lines for you if you want professional blue lines for your portfolio, but it may be better to choose a printer from the Yellow Pages than to use a street franchise.

- If you make your own blue lines, be sure to add registration marks to allow for the color art and the line art to be lined up properly. Registration marks can be as simple as a cross added to each edge of the artwork.

◄Guides for color

At the repro house, the black-line art on the acetate and the colored blue-line art are put together using the registration marks as a guide, and are shot using a process camera to create the film for printing.

Blue lines are an excellent way to **color cartoons,** to give a **printed result** that's very **close to the original artwork.**

Alternative Materials and Composition

Of course, you are not bound by whatever conventions exist in cartooning. You don't have to use pen, brush, ink, and flat color. You are only bound by your imagination as to what materials to use.

You may want to try using adhesive transfer sheets of dot and line patterns, otherwise known as Letratone, Zipatone, or Benday patterns, to create tones in your drawings. These sheets are available at all good art supply stores, and come in many dot and line patterns, as well as more esoteric patterns, such as leaves or bones. Be warned, however, that transfer tones are expensive, can be messy, and can also be infuriating to use. Also note that some patterns will turn into a gray mush when printed. Ask your dealer for the optimum sizes for print work. Otherwise, be up to date, and use computer paint programs.

Airbrushes are popular with some cartoonists for adding tonal values to their artwork, whether in black and white or in color. Pros for the airbrush include the smooth and slick look it can give your artwork, and the ease of creating some special effects. The cons include the cost (airbrushes aren't cheap, nor is a good compressor to create the airflow), the necessity of an open workspace (to avoid breathing in the pigment spray), and the amount of practice needed to become adept. However, if you can afford the time and money to become well-versed with the airbrush, you will find that it will open up many creative doors.

USING TRANSFER SHEETS

Apply adhesive transfer sheets to the originals by cutting out the shape of the area you wish to tone, peeling the cut area of pattern away from the backing paper, and placing it over the area to be toned.

BINDING THE ARTWORK

Trim away the excess areas, and bind the area to the artwork by "burnishing," or rubbing down, with a burnishing tool or the back of a spoon.

◄ ► Compressor and airbrush

Airbrushes work by firing a stream of compressed air over the top of a reservoir of pigment. This creates an aerosol effect and applies the pigment to the art surface in a fine stream.

Using **other methods** lets you explore
different areas of your creativity.

SEE ALSO

 Choosing Equipment **20**

 Pens and Markers **90**

Reprographics **148**

► Colored paper

Drawing on toned or colored paper can create a unique effect. In this example, cartoonist Charles Adlard used black charcoal and white chalk on gray paper to create the wartime atmosphere in the Trentino Mountains during World War I in his work entitled White Death.

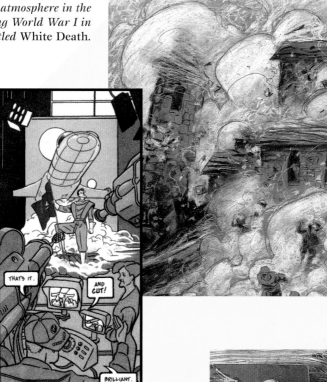

► Markers

Using colored markers on the back of your photocopied originals (the side that doesn't have the line art) can be a great way of coloring your artwork. Make sure that the markers will show (or bleed) through the paper, so that you can see the color underneath the lines when you view the art the right way up. Rian Hughes used this method for creating the subdued tones in his work entitled Dare.

Over to you...

- Try using different household objects to make marks. Everything from a comb dipped in ink to a used match can add an additional dimension to your cartoons.

- Use a photocopier to duplicate images. You can use these images as is, or you can distort them by moving the original as you copy it. You can even draw over the copies to add further effects.

- Using photographs as part of your composition can lead to many interesting effects, and can even evoke a sense of verisimilitude if used in the right way.

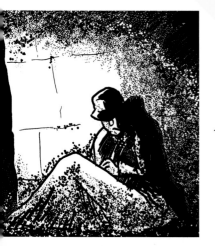

◄ Splatter effects

Using something as simple as a toothbrush dipped in ink can create great splatter effects. While holding the toothbrush over the artwork, drag your finger quickly over the bristles toward yourself.

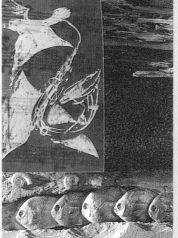

◄ Collage

Dave McKean is a great exponent of using collage in his originals. Using found objects that he sticks to his originals, he adds textures and an additional dimension to his art.

Chapter 6
Materials & Methods
Digital Media

Digital media refers to the ever-increasing **use of computers** by cartoonists to help them create. Some cartoonists who have embraced this new way of making cartoons have gone over to a **totally computer-driven workflow;** that is, they do everything on the computer.

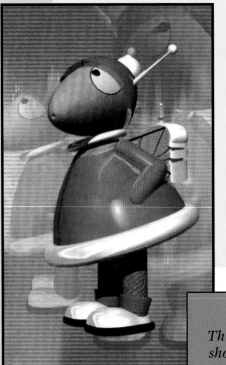

This 3-D model by Matt Petch shows excellent use of lighting and just how well 3-D can be used to create cute characters.

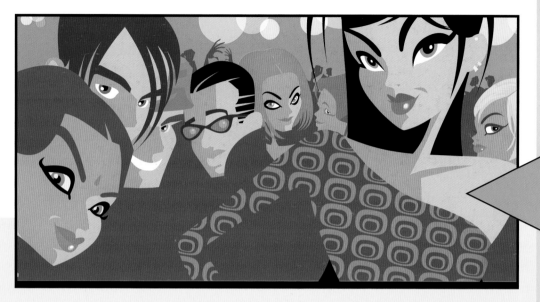

Others, more warily, have just started to **dabble with digital tools.** Whatever camp you fall into, you'll find that **the computer is a part of the cartoonist's toolbox** that you can't ignore.

Drawing with a Mouse or Graphics Tablet

When you first start to use a computer for your cartoons, you will have to decide whether you're going to use the mouse as a drawing tool or whether you're going to make a further investment by buying a graphics tablet.

Using a mouse is fairly routine for most of us. As the mouse moves, so does the cursor on screen (usually in the form of an arrow). In this way you can point to and select things. Additionally, a mouse has one or more buttons that let you click on objects to select them or drag objects around the screen. Using an art program (such as Photoshop or Paint Shop Pro), you can draw lines, fill areas, and make shapes using the mouse. It can be very tricky to use the mouse in this way, especially for intricate drawing, but many cartoonists have become used to this. Others have bemoaned the inflexibility of the mouse and have moved on to the graphics tablet.

A graphics tablet consists of a flat drawing surface and a special pen or stylus. It connects to the computer through a wire

A graphics tablet can take some getting used to. But **with practice** many cartoonists prefer it and elect to **use the mouse for** what it was designed for: **pointing.**

"MOUSEWORK"

With practice you can become adept at using your mouse for drawing. Take a normal pencil drawing, enlarge it on a photocopier, and then trace it with a mouse in a paint program. You may find that slowing the speed of the mouse helps; you can do this by clicking on the mouse option in your computer's control panels.

Here, the artist follows the drawing with the mouse; note the size of the artwork.

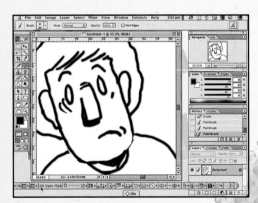

The image as produced on screen. After the artist has finished he can go back and clean up the on-screen art.

SEE ALSO

Choosing Equipment 20

Alternative Materials and Composition 108

The surface of the graphics tablet can be used to trace through paper.

and can be used much like a real pen or brush, except that the marks you make appear on the screen not on paper. Through a process called mapping, where every pixel on the screen is reflected on the tablet's surface, the cartoonist can draw quite naturally. Indeed, with a program like Painter, which replicates natural media such as ink, paint, and canvas, the cartoonist with a graphics tablet can create comparable work with less fuss than when using the actual materials. The only drawbacks are that tablets are expensive and getting used to looking at the screen while drawing on what amounts to a lapboard can be difficult.

The pen works by sending position, tilt, and pressure information to the computer.

Over to you...

- If you decide to use the graphics tablet, pay special attention to setting it up to reflect the way you work.

- Experiment with the settings on a graphics tablet and use it in paint programs. Can you:
 - simulate a fine sable brush or a splattery airbrush?
 - create effects by using tilt?

- Use the pressure function of your tablet to draw realistic folds in clothing.

When used with a program like Photoshop or Painter, the graphics tablet allows you to use unlimited variations on different tools. By experimenting with settings and tools, there is no limit to the effects you can achieve.

You can change settings to suit your drawing style.

This is a scratch pad on which you can practice your penmanship.

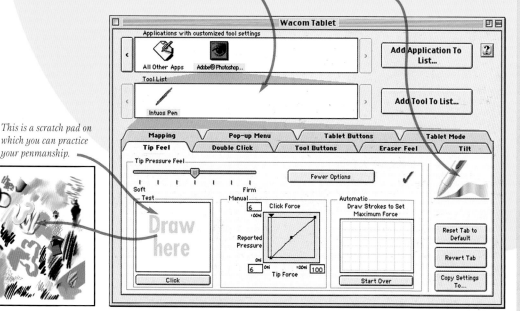

◄Software control

Most graphics tablets come with sophisticated software that allows you to control variables, such as the speed of the line being drawn on the screen. Other variables are pressure (most tablets allow you to create thicker lines by pressing down harder, just like a brush) and tilt (again, most tablets can tell at what angle you hold the pen and will control the line width appropriately —especially good if you use the airbrush function of paint programs).

Scanning

Even with the ease of use and adaptability that a graphics tablet can provide, most cartoonists still draw in pencil on paper first, ink their drawings, and then scan them into the computer, where they clean them up and add color. Even if you don't scan your work, chances are that your publisher will.

There are two main types of scanner: the high-end drum scanner found in repro houses and the more common flatbed scanner. Both work in similar ways. Artwork is subjected to an array of photo-sensitive cells that are drawn across it (in the case of drum scanners, the artwork is drawn across the cells) in a precise number of steps, depending at what resolution the artwork is being scanned. These cells measure the amount of red, green, and blue in the artwork (or tones of gray, or black and white, depending on settings), and digitize this information.

The most important thing to consider when scanning is the resolution. This refers to the number of pixels per inch (or centimeter) that the scanner uses to capture the artwork. This is typically measured in dots per inch, or "dpi." The higher the number, the larger (in terms of file size) and more detailed the scan will be.

It's rare that you'll get a perfect scan just by scanning alone. Chances are you'll have to correct certain elements. Typically, the image will have to be sharpened, and if it's in color, the color balance will have to be corrected. Programs like Photoshop or Paint Shop Pro have powerful algorithms incorporated that allow you to do this.

▲ Color modes and resolutions

Normally, line art, like cartoons, is scanned at over 800 dpi (1200 dpi is standard). This makes the file size very large but prevents the cartoon from appearing pixellated (like a series of little squares) when printed. Color art is scanned at a much lower resolution, typically around 300 dpi.

COLOR MODES

Every scanner can scan in a number of different color modes, most commonly black and white (or line art), grayscale, and RGB (or color). Like resolution, the more complex the color mode (bit depth), the larger the file size will be. Scanning a color picture collects more information per pixel than a piece of line art.

SEE ALSO

 Paint (or Bitmap) Programs 118

 Image Editing 122

 Storing Digital Files 124

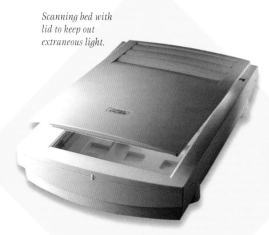

Scanning bed with lid to keep out extraneous light.

The higher the **resolution** of the scan, the **more detailed the image** will be... but the file size will get larger, too.

▶ Scanner software

The software used to control the scanner differs from manufacturer to manufacturer, but the premise behind each program is the same. Often you scan from within another program such as Photoshop, which uses a plug-in to control the scanner. First you create a preview scan after you've placed the artwork on the scanner, then you select the bit depth and resolution, pinpoint the area of the image you want to capture, and finally create the scan itself.

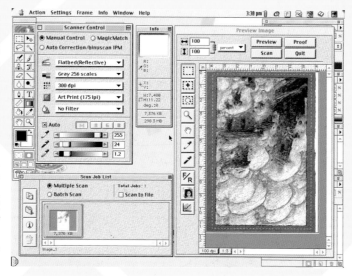

◀ Turning bitmaps into vectors

The advantage that a vector image has over a scanned image is that you can scale it to any size and have the image remain crisp and sharp. Although this isn't necessary in most cases, you may find that a particular job may require this ability (e.g. blowing up cartoons for reproduction in an exhibition). A program called Streamline is often used for this purpose.

Over to you...

Here's a handy method to get higher resolution scans from a scanner that can't physically scan at the resolution you want:

1 Scan the image at your scanner's highest possible optical resolution, but in grayscale (assuming 600 dpi and using Photoshop).

2 Resample the image using the "Image size" command to 1200 dpi.

3 Sharpen the image using the unsharpen mask filter (found in Filter – Sharpen). Use the following settings: Amount 500%, Radius 1, Threshold 5.

4 Use the threshold control (found in Image – Adjust) to force all gray pixels to either black or white, depending on their color (i.e., a 40% gray pixel will go to white, while an 82% gray pixel will go to black).

5 Change the mode of the image to black and white, or bitmap, using the 50% Threshold button. Voilà! You now have a 1200 dpi image from a 600 dpi scan.

Vector Images

Vector images are formed from mathematical algorithms that describe the image's lines, curves, and colors. These algorithms are part of a computer language called PostScript, the basis of most modern printing devices. At some point, your artwork is going to be converted into PostScript in order to print, so there are advantages in creating your images as vectors in PostScript format initially.

Programs like Illustrator and Freehand are used for creating vector images, and because of the way vectors are created, are termed draw programs (as opposed to bitmap programs, which are called paint programs). The learning curve for these programs is quite steep because, unlike bitmapped images, you don't create vectors by using a mouse or graphics tablet to "draw" the pictures on screen. Instead, a tool called a pen is used to create a series of lines and curves with points connecting each part of the line or curve. These lines and curves can also be filled with color, and they can be stroked (putting a color and thickness on the line itself). Additionally, the points can be either curve points (where the resulting lines are curves), or corner points (where the resulting lines are straight). In this way, complex shapes and figures can be made, and, because they are made up of mathematical functions, the file size is lower than a comparable bitmapped image.

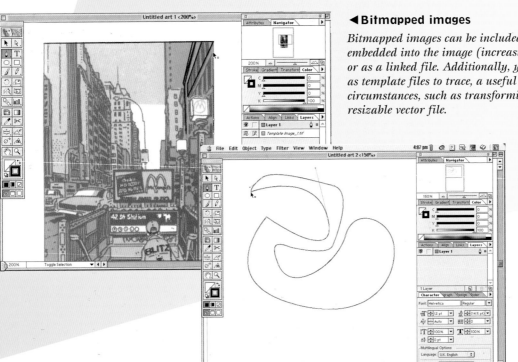

◄ Bitmapped images

Bitmapped images can be included in vector images, either embedded into the image (increasing the file size considerably) or as a linked file. Additionally, you can use bitmapped images as template files to trace, a useful technique in certain circumstances, such as transforming a bitmapped logo to a resizable vector file.

◄ Bézier curves

The very basis of vector drawing programs is Beziér curves; these form the foundation of the whole PostScript language. Created by using handles dragged out from points, these curves are difficult to control, but are worth the effort. They can be used to create extremely complex images with a low file size and can be reduced or enlarged without any degradation of the image.

SEE ALSO

 Drawing with a Mouse or Graphics Tablet 112

 Image Editing 122

One benefit of using a vector program is its superior text handling. Computer fonts are created using the same or similar technology as vector images, so you can stretch, reduce, enlarge, skew, or do anything else you can think of to fonts without any degradation. As a result, many comics now use specially made fonts in a vector program. Programs like Fontographer make creating lettering as easy as typing.

Using a font creation program, like Fontographer, first copy unusual fonts that you have seen elsewhere, and then try to create your own digitized font.

Over to you...

If you have access to a vector program, try using the drawing tools. The best way to learn how to use a vector program is to experiment with it. Try to:

- draw a circle using just four control points.

- use a combination of corner and curve points in the same shape.

- notice how tangents are used to shape curves.

Most vector programs can also export vector files in bitmap formats like TIFF, BMP, JPEG, or GIF. Be aware, however, that the vector images will be rasterized or turned into bitmaps (see Glossary, pages 152–153), and this will increase the file size.

◀EPS & SWF files

Vector programs can also export files in a variety of formats. The most commonly used is EPS (Encapsulated PostScript) because of its small file size and ease of use in page layout programs. Another frequently used vector format is the SWF. This is normally used by the program Flash to create animations for the Internet.

Vector images can be **enlarged or reduced** to any extent and **still remain crisp,** making them **perfect for logos and lettering.**

Paint (or Bitmap) Programs

Unlike vector programs, paint programs use a freehand approach to creating artwork, with the artist using a mouse or graphics tablet to "draw" the required image. While paint programs use a grid metaphor to create images, vector programs use mathematical functions.

The term "bitmap" accurately depicts how a paint program works. The name comes from "bit," the smallest unit of computer storage, which can be either 1 or 0, and "map," computer-speak for a table, like a spreadsheet or a grid. Therefore, a bitmap is a grid that describes where bits are located. And this, when you think about it, perfectly describes an image that has been created in a paint program or has been scanned. A real-world example of a bitmap is a chess board; it's a grid made up of 64 squares, where the first square is white, the second square is black, and so on. When we use a bitmap program, either with a scanned image or an image created totally in the program, we are effectively filling in cells in a grid with a color. While these programs are easier to use than a vector program, the file sizes that arise with bitmaps can be huge. A full-color A4 (approx 8" x 11", or 20 cm x 28 cm) image is around 34MB uncompressed. They will, therefore, use up a lot of a computer's memory and will significantly slow down an old computer or a computer that does not have a powerful memory.

brushes palette

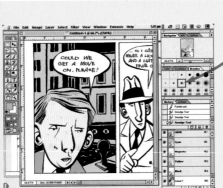

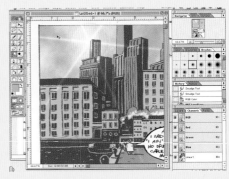

Selecting brushes is easily done by using the brushes palette. You can change the size, shape, and angle of the brush. If you use a graphics tablet with a paint program, the pressure and angle of the pen corresponds exactly to the width and type of line you produce, creating an ever greater degree of realism.

An essential part of paint programs is plug-ins—programs that "bolt" on top of the main program to give lots of exciting effects and additional tools. With plug-ins you can create blurs, flares of light, and other effects. However, plug-ins can be easily overused; a sparing use of plug-ins is much more effective than an overpowering use. Less is more.

This image illustrates how effective a plug-in can be by the addition of a lens flare at the top left.

SEE ALSO

 Scanning 114

 Image Editing 122

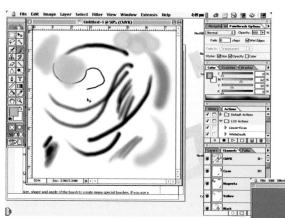

◀ ▼ Photoshop and painter

Programs like Photoshop and Painter include tools familiar to any artist— brushes, airbrushes, and pencils—as well as the ability to change the size and color of the brush quickly. Painter reproduces natural media like oils, impasto, and watercolors very well, giving a realistic effect to computer art.

Paint programs are very **versatile.**

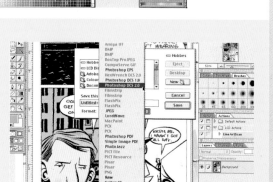

Over to you...

- Experiment with all the tools that bitmap programs offer. If you're used to drawing with a pen, try using the brush tools to create a different type of line.

- Try drawing a face at different resolutions and then print the result. Note that as you increase the resolution, the image becomes less stepped or pixillated. What is the effect on the file size and the speed of printing when you do this?

- Plug-ins can be very effective if used properly. Study the options your program offers and experiment to see what effect they can give. Really push the envelope by using the most extreme settings. Can you think of some examples of when these effects would be handy?

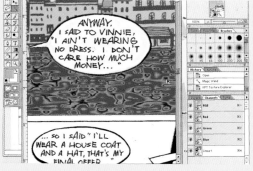

Because scanned images are bitmaps, you can scan in photographs and physical objects like bricks to add to your artwork. Many cartoonists experiment with these techniques to get effects that otherwise would be very hard to achieve.

Like vector programs, paint programs can output files in many different formats. The most popular format for publishing is the TIFF file ("Tagged Image File Format"), because it can be compressed to take up less disk space. Other useful formats are JPEG ("Joint Photographic Experts Group") and GIF ("Graphic Interchange Format"), used mainly in web publishing. (See Glossary pages 152–153.)

Most cartoonists **become adept with bitmaps very fast.**

3-D Modeling

One of the major movements in digital art is the emergence of 3-D programs. If you look at most video games or films, you can see what an impact the introduction of these programs has had. In cartooning, too, some artists have experimented with 3-D to create more realistic worlds for their characters. Some cartoonists even create their characters using 3-D software.

3-D programs are similar to vector programs in that the images are created using a system of curves and lines. Once you have established your framework, you can then create surface textures, whether rock, metal, or skin, to go over that framework. This is called modeling and requires practice to master, as well as a great deal of computer power. Most programs also allow you to use a system of primitives, like cubes, spheres, and cones, to create 3-D images—much like traditional cartoonists have built up drawings using squares, circles, and ovals—and bitmap programs to create surface textures. The more powerful (and expensive) programs can create fur and hair and even animate characters.

3-D programs range from affordable to wildly expensive.

CREATING A 3-D IMAGE

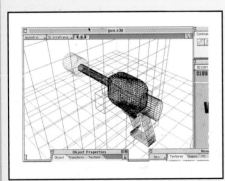

1. To use a 3-D package to create a futuristic gun, begin by putting together basic shapes such as cubes, cylinders, and spheres.

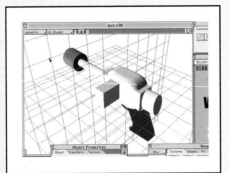

2. Next, create the lighting you want to appear on the gun; this example is lit from the left and slightly above.

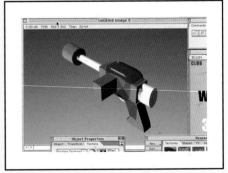

3. Finally, apply surface textures to the model, then save your work. You can also bring the model into a paint program to add extra surface detail.

SEE ALSO

 Image Editing 122

 Animation Character Design 142

Computer Game Character Modeling 144

▶ Backgrounds in 3-D

Some 3-D programs are better for some things than others. If you want to model realistic backgrounds, then Bryce is a good choice. Here, cartoonist Scott McCloud has used Bryce to create atmospheric shadows and an impressive backdrop.

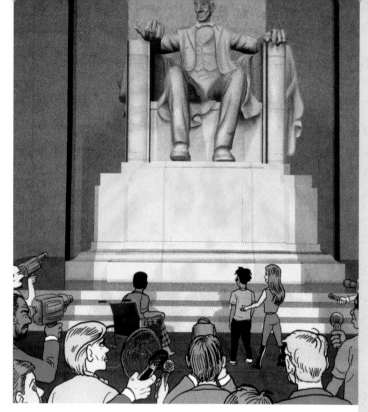

Shop for
the best package in your price range.

◀ Posing people

For modeling people, the program Poser is unrivaled in its price range. Figures, hands, faces, and feet can be modeled fairly realistically with this program.

▶ Logo design

You can buy plug-ins for bitmap and vector programs that will allow you to use 3-D to a lesser extent. Here we see an example of a logo that Brad! Brooks created using Illustrator and Kai's Vector Effects.

Over to you...

- Just like normal drawing, most 3-D images can be broken down into a series of shapes. What shapes would you use to create:

 – a tank from the side?

 – a gorilla from the front and slightly above?

 – a mountain range as seen from a helicopter hovering above it?

 – a human face in a three-quarter view?

- Light sources are very important in 3-D modeling. What would the effect be on your model of a tank if the light sources and angle of view were changed?

Image Editing

Strange as it may seem, the programs Photoshop and Paint Shop Pro, along with many other paint programs (Painter being a notable exception), weren't invented to create images from scratch. Instead, their primary use, even today, is in the field of editing already created images, like scanned photographs.

The range and versatility of the tools and filters in image-editing programs allow the cartoonist to create effects and corrections quickly and easily. You can color cartoons using the entire printable gamut—and with stunning effect. Want to use photographs or realistic textures in your work? No problem. Want to get an airbrush effect without having to use one? Easy. Using the tools in any image-editing program opens a world of creativity. For example, the paintcan can deliver filled areas far quicker than a brush can. The gradient tool allows you to create a smooth blend between two or more colors. You can even correct mistakes on original artwork before you do anything else to it using the pencil and brush tools. Blemishes and scratches from the scanner can be removed by using the Rubber Stamp.

With an **image-editing program** you can **let your imagination go wild** with no mess or fuss, as there's the **invaluable undo function** for those times you make a mistake!

LAYER EDITING

A recent innovation is layers. Think of layers as pieces of transparent overlay that go over your base canvas. With layers, you can create multi-level images. You can even adjust the mixing of those levels. Some cartoonists use layers to color their cartoons, putting the line art onto a level that overlays the color so that it remains sharp, a bit like a blue line.

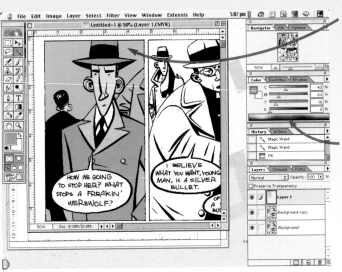

After creating a spot channel to hold the line art, select the area to be filled, and then choose the color channels to apply the color. After finishing the fill, merge the line art channel into the CMYK channels and output as a CMYK file.

Image-editing programs allow you to see the color channels in an image and work with them. Most printed color material is made by mixing cyan, magenta, yellow, and black inks (known as CMYK) together to create full color. In Photoshop, you can see these channels and add color to them.

SEE ALSO
 Scanning 114

 Advertising and Packaging Illustration 136

You can even manipulate photographs to create cartoons using Photoshop, or other image-editing programs (with plug-in filters that you can buy). Stand-alone programs like Goo can create weird and wonderful effects.

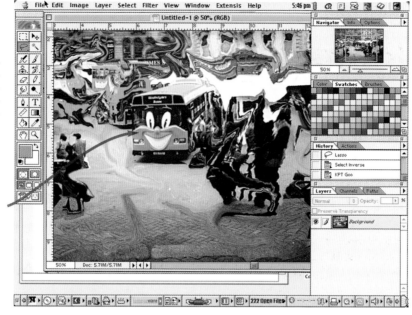

▲ Photograph manipulation

Because image-editing programs are bitmap programs, you can use anything that you can scan or capture with a digital camera. And, with layers, you can adjust transparency, color balance, and more.

Effects like lens flares, blurs, and gradients can also be added at this stage to create additional drama.

Colors can be chosen from a palette of swatches that are preloaded, or you can choose your own colors using sliders to adjust them. These colors can be saved to the existing palette or a new one for reuse. You can even use Pantone, Toyo, or Trumatch swatches.

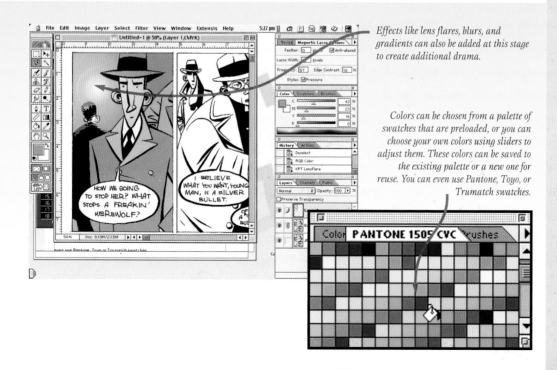

Over to you...

- Try scanning a cartoon and coloring it using Photoshop or a similar program. You might find it easier if you scan it in grayscale, equalize the threshold (see page 114), and turn to a bitmap. Then use the color mode controls to make the image a CMYK one. You'll discover that your colors go right to the edge of the lines instead of leaving a hairline gap.

- Scan the same cartoon again and color it using a narrow range of colors. Limit the palette to one or two colors to create an "atmosphere."

- Scan photographs of friends and manipulate them to differing degrees. Can you use these images in your artwork?

Storing Digital Files

Once you've started scanning and creating images on the computer, you'll soon find that no matter how large your hard disk is, eventually it will run out of space. And the fuller the hard disk becomes, the greater the chances of it crashing when it is needed most.

Storing electronic artwork is much like storing any other digital file. There are specific formats for artwork (like TIFF "Tagged Image File Format," EPS "Encapsulated Post Script," etc.), but otherwise it's a bunch of 0s and 1s like a spreadsheet, database, or any other file on your computer. The main thing to remember is to back up your hard disk regularly. This is vitally important! Without backing up, you could lose everything in one fell swoop.

Basically, backing up means copying your entire hard disk to some other storage medium periodically. There are programs available to help you do this, especially if you want to do cumulative backups (i.e., backups that you add to over time, whenever you've gathered enough new material, rather than

backing up the whole lot at once). External hard drives are another excellent solution for backup—if you can afford one. You can also partition them, and use different partitions for different areas of backup. If your main hard disk is getting full, they're also great to give you more usable space. They're certainly the fastest of all the options, but also the least portable. Below are some other ways of storing digital files.

▼ Zip disks

Zip disks are removable hard disks that come in two sizes, 100MB and 250MB, and need a special drive to read/write them. The disks are fairly expensive unless you buy them in bulk, but they are good for sending files to publishers and repro houses. Watch out, however, because most repro houses don't update equipment very frequently.

▲ CD writers

The best all-around solution is a CD writer. Using special writable and re-writable CDs, you can fit up to 650MB on a single disk, allowing you to back up large hard disks cheaply. They're excellent for sending to publishers because they're very robust and contain a lot of information. You can get CD writers that connect to Macs and PCs externally or internally.

SEE ALSO

 Choosing Equipment 20

 Scanning 114

 Worldwide Web Publishing 150

It's a law of nature that **your hard disk will crash** just as you're saving your masterpiece...

▶ Tape backup

If you have lots to back up, DAT ("Digital Audio Tape") drives are ideal because each tape has a large capacity and they're fairly cheap. They're not very helpful if you need regular access to that information, however, because finding a particular piece of information involves a lot of rewinding and forwarding. Moreover, they are useless for sending to publishers.

...which is why **you always need to back up.**

▶ E-mailing files

Don't try to send anything too large over the Internet using an e-mail program— even if you've archived it. The maximum is about 10MB at a time, and even this can be risky. If you do have to send large files, ask your publisher or repro people if they have a File Transfer Protocol server that you can use to upload.

Over to you...

- A good strategy is to ask your publisher how to submit digital files and on what medium. This may save you lots of time and heartache.

- Ask your nearest computer sales outlet what they charge for storage options. Also check out the Internet (use a search engine like Google or Hotbot); chances are you'll be able to get the same options cheaper, even taking shipping into account. Often purchases made with a credit card are guaranteed by the credit card company.

- Ask friends with computers what backup strategies they use.

- If all you need is approval for your work, why not fax it? It's cheap, easy to do, and every publisher has a fax machine.

- For sending files, most Internet cafés and repro houses have ISDN ("Integrated Services Digital Network"), a fast method of connecting to the Internet.

Chapter 7
Cartoon Formats

When you mention 'cartoons', most people have a preconceived idea of what you mean, whether it is **Saturday-morning TV animation,** or a **single drawing 'gag'.** The reality is, however, that there are a **myriad of different ways in which cartoons can be used.** This chapter will show you how all the techniques and methods you have

The most recognizable form of cartoon is the single gag cartoon that conveys the joke instantly. Good cartoonists should be able to see humour in any situation, no matter how grim.

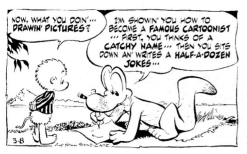
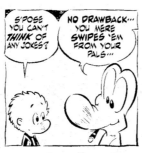
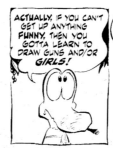
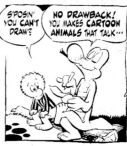
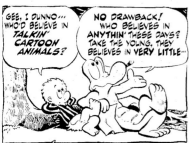
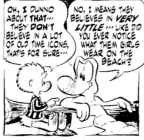
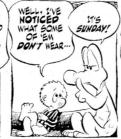
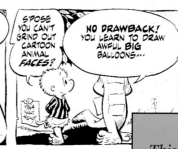

learned can be used in a **variety of ways for practical, commercial usage.** We will look at **single 'gag' cartoons** - possibly the most common and well recognized - through **caricature and into illustration, design and self-published comics.** All of these formats work when **the cartoon manages to communicate ideas quickly, efficiently and economically.**

This newspaper strip cartoon is by the legendary Walt Kelly, whose Pogo strip ran for over 25 years in the USA, from the late 1940s to the 1970s.

Gag Cartoons

Probably the most instantly recognizable of all cartoons is the classic "gag" cartoon. This is usually a single joke told in one picture and is essentially a one-liner.

Gag cartoons can be based on just about anything, from current events to simple people observation. The key to how they work is the simplicity of their humor and the empathy of the reader.

When drawing for magazines or newspapers, be aware of their layouts and how much space you are likely to have. Scale your artwork up or down accordingly.

To **develop a gag** you can **start with anything...**

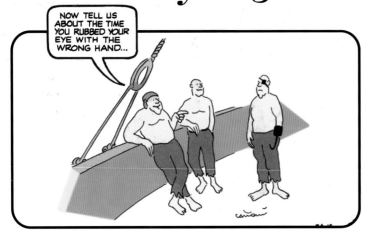

...an overheard conversation, a quote from a **newspaper,** a purely **visual joke,** or a humorous **event.**

When drafting ideas for gag cartoons, try to come up with several ideas by working in a stream of consciousness before settling on a final design. Here is a typical example.

Gag cartoons can be effective in illustrating text to create a visual pun. For example, this image might be accompanied by text that reads "spot the ball."

By pairing the above image with the same text, "spot the ball," you can create a new gag with an entirely different slant. In this gag, scale is used to create a sense of absurdity.

SEE ALSO
 Cartoon Texts 52
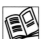 Book Illustration 138
Editorial Illustration 140

◀ The Addams Family

Charles Addams created a series of ghoulish, yet humorous strips for the New Yorker, which spawned the famous Addams Family television series and films. This particular gag was used at the end of the first film.

▶ Old Skool Daze

When it comes to writing the caption, there are a variety of ways in which the text can be presented. The most traditional way is to typeset the text underneath, like in this Ronald Searle cartoon from 1946.

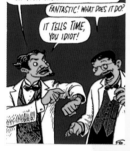

CARLSON! I'VE INVENTED A TIME MACHINE SMALL ENOUGH TO WEAR ON YOUR WRIST!

FANTASTIC! WHAT DOES IT DO?

IT TELLS TIME, YOU IDIOT!

▲ Think of a theme

It may help to think thematically when working on ideas for magazines. This gag cartoon has an obvious science slant and was syndicated in the scientific magazine Frontiers.

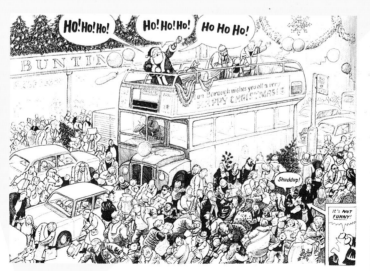

Over to you...

- Picture as many scenes, topical events, and humorous instances as you can, and work out how they can be turned into simple one-liners.

- Think about where the cartoon will be appearing. Are the format and topic appropriate?

- Take one simple theme, for example a monkey and an elephant in the jungle, and see how many jokes and cartoons you can create from that starting point; you could add incongruous objects, such as an umbrella or roller-skates. You should be able to come up with at least four or five jokes.

◀ Christmas chaos

Posy Simmonds goes for a more comic-book-like effect than the traditional method, using word balloons and an extra panel inserted in the bottom right-hand corner to bring emphasis to the figure in the crowd.

Caricature

Another popular form of cartooning that most people recognize is the caricature, perhaps from street artists drawing an amusing picture of themselves, their friends, or their family.

Caricatures rely on the rule of twisting and distorting the physical attributes of people to create an exaggerated effect. The key is to examine an individual's features (most commonly on the face) and play around with them—increase the size of the nose, reduce the size of the mouth, etc. On some people this feature, or features, will be obvious and thus quite easy to focus on (Prince Charles's ears, or Richard Nixon's nose, for example). Others will be trickier, so careful examination of the subject is needed. Remember that the skill is to make the person recognizable, and not some sort of sideshow freak!

1. Study the face of your subject closely. Sometimes caricature can be easier if the subject "makes," a face, particularly if his or her face has no obvious features to exaggerate.

Caricatures are all about **observation and exaggeration. The aim** is not to necessarily flatter or insult but to **create a recognizable, cartoon version of a person.**

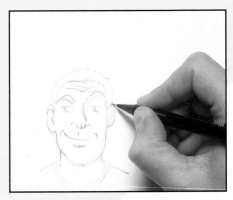

2. Note that the artist has exaggerated the line on the subject's nose, raised the eyebrows higher, and broadened the smile.

◄ **Recognition**

This caricature of a younger Prince Philip by David Low focuses on his body shape and posture by lengthening the arms and legs and reducing the size of his head. However, the facial distinctions are very clear, and the whole drawing is very recognizable as the original person.

SEE ALSO

Working from Observation 74

Observation to Artwork 76

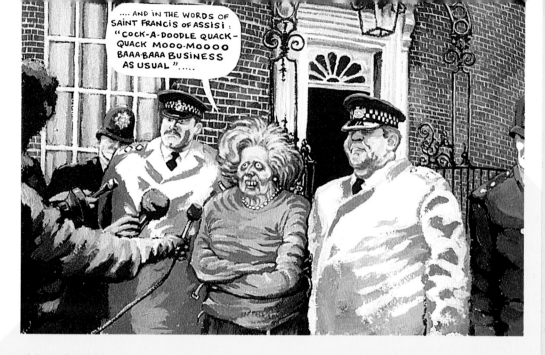

▲ Leaving home

Often done for amusement, caricatures can be harmless, but in the right hands they can be used as a scathing tool of social or political commentary.

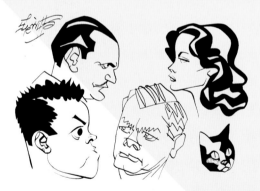

▲ Minimum lines for maximum effect

The main work on offer for caricature artists comes from illustrating entertainment articles for magazines or newspapers. This drawing, for Punch magazine in 1949, is of the principal actors from The Third Man (Orson Welles, Trevor Howard, Joseph Cotton, and Valli) by Robert Stewart Sherriffs.

▼ Bad Budget Bill?

Often an idea may not be immediately obvious, but is intended to draw the reader in. Here Pat Oliphant's attack on Bill Clinton likens the ex-US President to a street hustler "fixing" his budget. Note how the nose has been exaggerated and note the con-man style clothes.

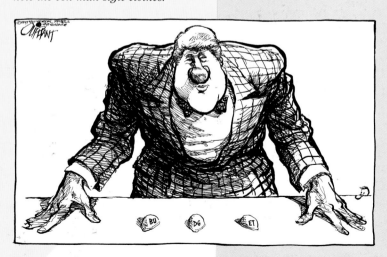

Over to you...

- Look at photos of famous people and decide what their most prominent features are, then caricature them. Are they still recognizable? If not, tone down the distortion.

- Offer to do caricatures of friends and family. You'll be surprised how many people will be willing to sit for you.

- Think of objects or animals that the person you are drawing resembles. Perhaps there is a connection with an occupation or pastime that you can incorporate. For example, a person with a particularly large nose could be drawn as a Concorde or as an anteater.

Comic Strips

Comic strips work differently from gag cartoons or caricatures in that they are a series of sequential drawings that convey the passage of time as opposed to a single image that acts as a snapshot in time. Strips are a slightly younger artform than standard cartoons.

Comic strips generally appear in two forms. The first, the classic newspaper strip such as *Peanuts*, *Calvin and Hobbes*, or *Doonesbury*, is probably the most common. These strips typically appear as a series of three to four individual drawings, known as panels, that tell a story or short joke. Often they will be self-contained vignettes to be read by the casual browser, but they can also be collected together to create a larger story.

The second, the more traditional comic format of a book or magazine, has approximately 24 pages, with four to ten panels on each page. While these can also be self-contained, they are more likely to be part of a series telling a longer, more complex story due to the luxury of expanded space.

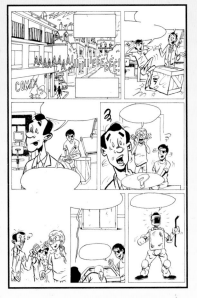

Before starting your actual cartoon strip, think about writing a script. This will give you a clearer idea about what each panel will contain, along with any sound effects, dialogue, or "stage directions" you may need.

▼ **A world of possibilities**
Very often comic books are associated with superheroes, but they can be used to cover any genre or story you wish to tell.

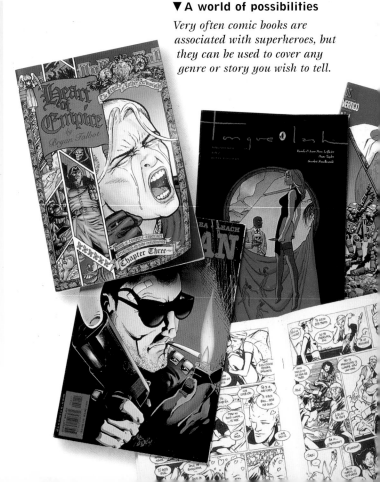

 Animals 44

 Cartoon Texts 52

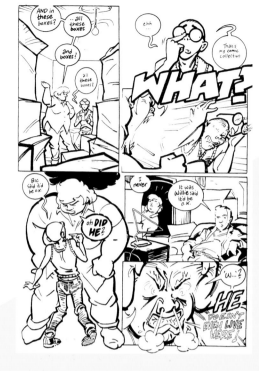

◀ Design before drawing

Comic books use a range of layouts, from traditional nine-panel grids to more open and complex versions. The skill is to make the eye follow down the page from top left-hand corner to bottom right in a zigzag. This page, from Ed Hillyer's Time Warp: End of The Century Club, *looks quite complex, but is actually based on the page being split into quarters.*

▶ Pacing your panels

The key to all comic strips is their continuity from panel to panel, and from page to page. The important aspect is to make sure the story flows smoothly. Here is one page from Lewis Trondheim's The Fly *that shows perfectly how you can pace and tell a story, even without words.*

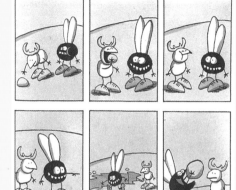
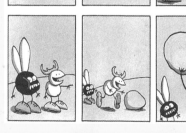

Over to you...

- Write a script, putting all your ideas and thoughts down in a clear story, just like a film script. Remember to include a definite beginning, middle, and end to the cartoon.

- Draw thumbnails of your pages first, and plan out the flow of the eye over the page. Keep it simple—anything too complex may confuse the reader.

- Sketch several different-length cartoons: a four-panel strip, a one-pager with nine panels, and a three-page story with as many panels as you like. This will teach you how to pace your stories for different formats.

It is important to **pace** your stories, as **timing** will add a new dimension to your work.

◀ Newspaper strips

Comic conventions can also be used in cartoon strips in newspapers, as in Frank Cho's Liberty Meadows. *Here a large amount of space has been used in the pacing of the story, a luxury that is usually reserved for the big Sunday color supplements due to space restrictions in the dailies.*

Political Cartoons

Throughout history, political cartoons have had a special status among the intelligentsia, and are seen as biting satires that have standing. They are part of democratic political discourse and can help provide a commentary on the complex political and social issues of the day.

In political cartooning it is very important to make sure that the message is clear. Some artists would even state that the idea or concept is more important than the artist's talent, for without the topical edge they are just another cartoon. When looking for ideas for political cartoons the most obvious places are newspapers, magazines, and the news on radio and television. You need to write down anything that catches your attention, whether it is a soundbite or a particularly unusual picture of a politician. It is important to do this every day, because many political cartoonists need to produce a cartoon that will appear in the next day's newspaper.

British cartoonist Steve Bell once said, "Pictures... can convey all sorts of meanings, both intentional and unintentional. Images are powerful but should not be sacred." Certainly this is how many cartoonists regard politicians—powerful, but not sacred. In fact, it is seen as the duty of every political cartoonist to ridicule, mock, and parody every politician, regardless of the politics.

Caricature is a vital tool for all political cartoonists.

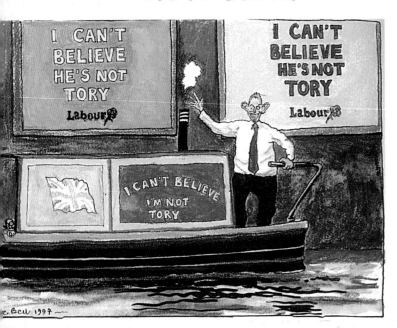

Learn this skill first, because many of the people that you draw should be instantly recognizable to millions as presidents, prime ministers, and other world leaders.

◄ Topicality

This cartoon of British Labour Party leader Tony Blair on the campaign trail in 1997 is based on a photo opportunity taken on a barge in Bristol. It is combined with campaign posters that paraphrase a popular product of the time—"I can't believe it's not butter"—thus highlighting the similarities between the two parties' policies. This is an excellent example of taking separate topical elements and using them to make a new point.

SEE ALSO

 Working from Observation **74**

 Maintaining an Idea Bank **78**

 Working from Reference **80**

 Caricature **130**

▶ Social injustice

If you feel strongly about a subject, avoid satire, as it will weaken your message. Some of the most enduring cartoons can be as powerful as photojournalism. This stark image, by Pat Oliphant, was drawn the day after the 1989 massacre in Tiananmen Square.

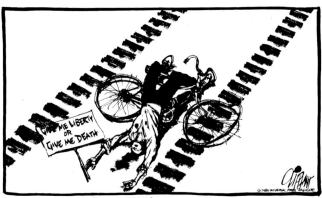

REMEMBER TIANANMEN SQUARE

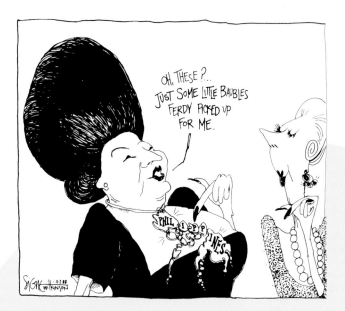

◀ Social commentary

Symbolism is often used in political cartoons. This illustration by Signe Wilkison depicts Imelda Marcos with the Philippine archipelago as trinkets, highlighting the way she treated the country during her husband Ferdinand's reign.

▶ Socialism?

Politicians are often depicted as animals. Here is Boris Yeltsin, the former Russian premier, shown as a cat surviving his political battles to maintain control over the country. However, try to avoid the obvious clichés of corrupt politicians as pigs.

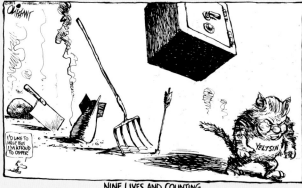

NINE LIVES AND COUNTING...

Over to you...

- Practice drawing caricatures of famous politicians and personalities until you have a look you want.

- Keep abreast of the news and politics at all times. It is your major source of ideas, and you never know when something important will happen.

- Try to keep a balanced political stance. Remember that not everyone will have the same views as you.

- Learn to draw quickly. Often newspaper editors will ask for a cartoon in just a few hours!

- Political cartoons rarely appear in color; most are in black and white because of the need for fast reproduction in newspapers.

Advertising and Packaging Illustration

Working for an advertising agency can be one of the most lucrative ways of using your cartooning skills. However, there will invariably be intense deadlines and many revisions before your client is satisfied.

Most advertising jobs start with a brief (a series of documents and ideas) from the company that will clearly outline what is required, whether it is for a one-page ad, poster campaign, packaging, television ads, or a combination of all four. There will be an explanation of the product, details of the target audience, and any other essential information.

Think about your cartoons and design in context...

▶ **Big, bright, and bold**

This advertisement for a computer game is aimed at the youth market, hence the bright colors and flashy graphics. It represents speed and excitement, mixed with a cheeky element in the pun "Safe Cyberdeks." It was created on a computer using Adobe Illustrator software.

It is crucial to follow the brief as closely as possible. If the brief is looking for something with cute, fluffy rabbits, and you draw elephants, the client won't be pleased—and you won't get paid!

You will need to complete several rough drawings for submission before a final design is chosen. You will also be expected to talk about your designs and justify your reasons for creating them—so practice your presentation skills. Once the rough has been approved (with possible additional alterations), you will be free to create the final artwork. However, don't be surprised if the client turns around at this point and asks for more changes, or a complete restart—that's advertising!

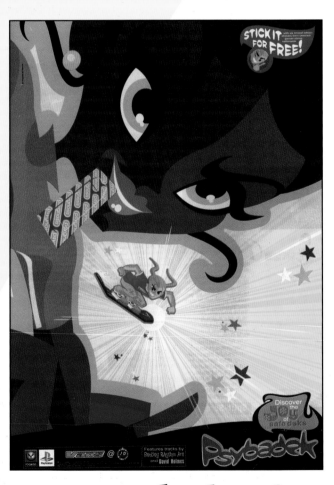

...do they **do the job** required?

Thicken the lettering

Reduce the turban

Lose the beard

Often the Art Director or the client will ask for changes to be made to the rough design.

Make into silhouette

Different colors on carpet (yellow?)

Here is a rough for a new curry powder package. Note that the changes requested are fairly small.

The changes requested have now been incorporated, and the design is final.

Over to you...

- The golden rule is "Follow the brief!"

- Be prepared to have many ideas and sketch lots of designs. The client will want to have as wide a choice as possible.

- Don't be too precious about ideas that are abandoned. It's the client who is paying, so leave your ego at the door.

- Examine other cartoon ads and packaging, looking closely at the designs. What makes them work?

- Design some characters for a breakfast cereal box entitled "Chocolate Frosted Sugar Bombs."

Your **designs need to catch the eye** at a glance and convey enough information to **draw in the passerby within a few seconds.**

◄ All in a lather

Remember that your designs may be part of a larger plan, so learn to broaden your focus. This full-page ad was part of a larger campaign that used the "Cool Jules" character in a series of animations.

► Tony the Tiger and the rest of the gang

Cartoon characters on breakfast cereal boxes, potato chip bags, candy wrappers, etc., have become a common sight and are designed to appeal to young children. They also liven up what would otherwise be dull packaging.

Book Illustration

This form of illustration is one of the oldest in publishing. It is used to enhance the covers and interiors of books for both adults and children.

When designing a cartoon image for a book cover, it is crucial that you read the brief from the editor. This should include a copy of the book, or at least a brief outline, to give you a feel for the title. Then plan a single strong image as the focus—remember that this cover will need to stand out on the shelves among hundreds of other titles. The editor will expect you to do several rough drawings, showing different designs, before selecting the final version for you to complete.

While cartoon covers appear on many adult paperbacks, cartoon interiors are generally reserved for children's books. These come in two formats. The first is the large-format picture book, which contains large images and a minimal amount of text. These books are often created in collaboration with the writer, who will sometimes have a clear idea of what he or she is looking for, but who very often seeks inspiration from you as well. The majority of these illustrations are in color. The second type of illustration most often appears in paperback books, and is typically used to highlight certain aspects of the text.

▶ Words and pictures

It is the cartoonist's job to read the story and select the most appropriate and visually interesting text to illustrate it clearly. In this drawing by Chris Riddell from Dakota of the White Flats, *the illustration and text are well suited to each other.*

Dakota took a couple of cabbages and started to put them on the vegetable section of the stall.

Pat bent down to pick up a handful of cabbages as well. As she did so a book fell out of her overall pocket.

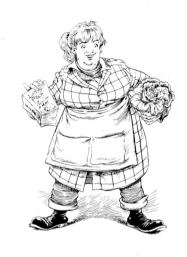

It was the latest Lassitter Peach novel.

'Oh dear,' said Pat, brushing the book clean. 'Mustn't get it dirty. This is one of his best. Has your mum read this one, Dakota?'

WORKING WITH THE EDITOR

Below is a script from a children's book describing a character. The artist must read this and come up with ideas for the editor to review. Here you can see the editor's comments.

"The professor was a strange bald man with glasses and thin lips. He was dressed in a lab coat with long, thin arms, at the bottom of which were two huge rubber gloves. He turned and stared at Oscar, raised a bubbling beaker of green liquid, and grimaced."

The face is good, but it needs to be more menacing! Also, make the gloves larger.

Nice atmosphere, but we need to see more of the professor's body. Keep the long arms from the first sketch.

Perfect! I like the added hunch and the unusual mouth. The gloves are right on!

SEE ALSO

 Cartoon Texts 52

Tone and Color Principles 100

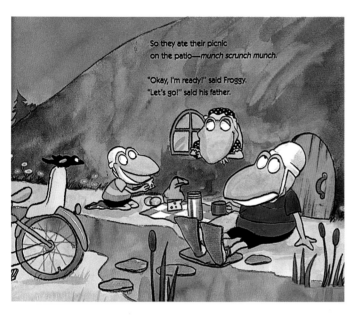

So they ate their picnic
on the patio—*munch scrunch munch.*

"Okay, I'm ready!" said Froggy.
"Let's go!" said his father.

◄ Dead space

*Here is an excellent example
of a children's illustrated book
that combines the text with the
image. Note how the artist has
left "dead space" for the text.*

Over to you...

- Practice doing rough
sketches in both color and
black and white for covers of
various books you know.
Think about the design and
color composition.

- Look at a variety of
children's books to study
how the artists and writers
have combined the text
and images.

Book illustrations can greatly **enhance the text** so that they **work harmoniously together...**

There's a PHARAOH in our Bath!

Jeremy Strong

► Book covers

*This cover by Nick Sharratt uses all the
important rules: a strong central image, bright
colors, and a large "dead space" in which the
publisher can place the title and author's name.
The last thing you want is to have your artwork
covered by essential text.*

...provided that the artist, writer, and editor all work **as a team.**

Editorial Illustration

Editorial illustration works in a smiliar way to book illustration. The main difference is that the work is mostly for magazines and other periodicals. In magazines there may well be several cartoon styles appearing on a single page.

Usually you will get a brief (including the column space you have to fill and the all-important deadline) from the editor and, ideally, the finished article to read. From the latter you will need to infer several things. If the illustration is a lead "illo" of approximately a full page, the theme or title of the article will generally become the subject of your inspiration. However, if you need to do a series of smaller drawings, then you will need to read the article and highlight particular aspects to illustrate. Sometimes the editor will pull out sections of text and enlarge it to complement the artwork.

Once you have selected the parts of the article you wish to illustrate, you need to send the editor a selection of thumbnail drawings, giving as many versions as you can imagine. Once approval has been given, you are free to complete the artwork.

Illustrations can be used on the **covers of magazines as well as inside.** Cartoon covers can be **novel eye-catching designs.**

SUBMITTING IDEAS

Several ideas will typically be submitted to the editor, who will then decide which picture best suits the article. Here are three ideas to illustrate an article on BSE (Mad Cow Disease) in England and France. The first two are rejected as being too cliché, but the third is chosen, as it retains the cow motif and mixes it with a jingoistic element. The chosen sketch is then drawn up in full color, scanned into a computer, and typeset into the magazine's design.

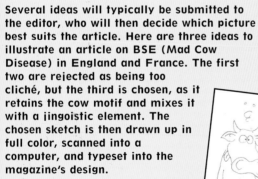
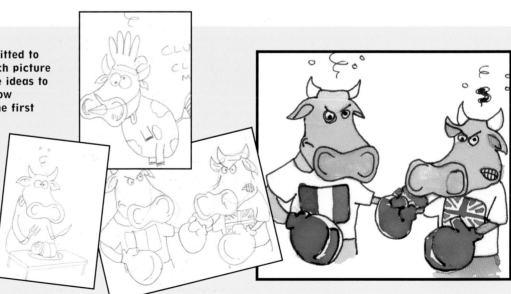

 Working from Reference **80**

 Tone and Color Principles **100**

 Book Illustration **138**

SEE ALSO

◀ Highlighting the point

Even the shortest article can benefit from an illustration that instantly draws the eye to the page. Note how the text is designed to fit around the artwork.

An appropriate type style is chosen to match the article and the artwork.

An amusing caricature is used to highlight this chapter.

A graphic has been dropped in to break up the background.

Another artist's work has beeen dropped in to create balance on the page.

Over to you...

- Look at an article in a magazine that hasn't been illustrated, select some text or part of it, and draw three cartoons to illustrate it.

- Practice your color and painting skills. Most magazines are full-color, and few take black-and-white illustrations. Besides, you will get paid more for color than for black and whites.

- Think about the page layout before you start to draw. How will the artwork fit? This is usually the editor's job, but if you have a specific idea, mention it.

◀ Magazine layouts

These cartoons by David Lyttleton are full-page illustrations highlighting each section of a magazine. They have been cropped and resized to use as a front page for each section. To create backgrounds and interesting designs in magazines, artwork is often used in this way.

Animation Character Design

Bringing your drawings to life can be a very satisfying and fulfilling experience, and because of this, cartoonists often venture into the world of animation.

Possibly the most important part of any animation project is the character designs. Without them, it is impossible for animators to maintain a consistent look throughout a moving cartoon. All animation studios hire cartoonists to create a variety of drawings of the key players for this very reason.

The character sheet will show the exact proportions of each person in relation to the others, and will show the figures from every angle. This will act as the blueprint for all future work on a project, and will probably go through several versions before the producers and director are happy.

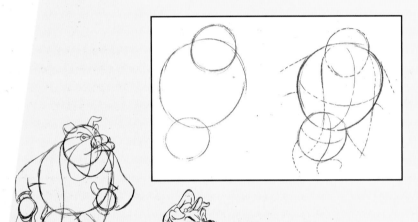

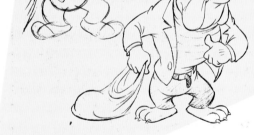

▼ Proportional representation

To create a character sheet, you will need to create a scale chart composed of several key lines that match up, highlighting the various points on the figure—remember the exercises from the Figures section (pages 26–27). Here is an example from the Batman animated series.

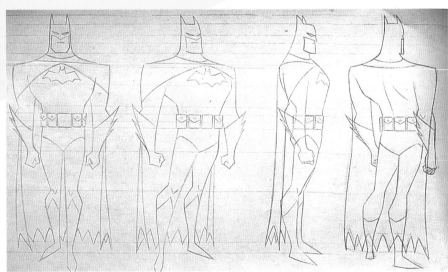

▲ Early sketches

The first ideas may start as rough sketches of costume designs, body shapes, and other ideas. Body shapes can be created out of simple forms such as ovals, oblongs, and circles. The drawings above, by the late Preston Blair, are a good example of how this can be achieved.

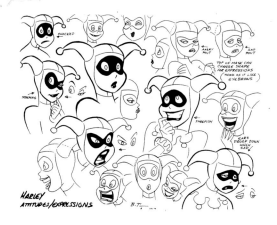

HARLEY
ATTITUDES/EXPRESSIONS B.T.

◄ Expressive designs

The next stage of character design is to look more closely at the facial and physical expressions. Practice some of the methods discussed in the Expressive Faces and Expressive Figures sections of this book (pages 34–37) to help you master these skills. You will need to produce as many emotions as possible.

Over to you...

- Practice drawing the same person or character from several different angles.

- Work on expressive faces and figures.

- Build up a repertoire of actions, angles, and poses for animals, automobiles, trains, etc.

- Remember that animation is all about movement, so try and add some fluidity to your work.

Animation is a collaborative effort, and your designs will go through many changes before the final draft is completed.

CHARACTER MOVEMENT

Working out how a character moves is an essential part of animation design. You can figure out how each character walks, runs, crawls, or slithers by drawing several "snapshots" as they take each step.

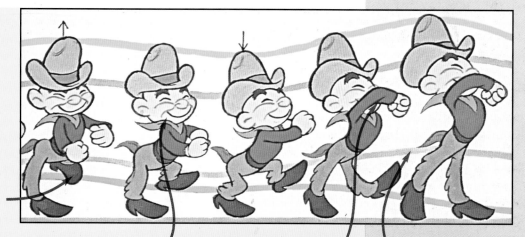

Each step forward is a cycle that starts with the right foot lifting off the ground and then coming down; the left foot is then raised and brought down.

In a good study drawing such as this one, the mood or personality of the character can be seen through movement and posture.

While you are concentrating on the legs walking, don't forget how the rest of the body moves. Make sure you show how the head bobs and arms swing, as few people walk stiffly.

A good trick to help you keep the rythm and flow of the body is to draw an undulating flow line through the key joints (hips, shoulders, etc.). This will help you to avoid jerky movements.

Computer Game Character Modeling

The fast-moving world of computer games is constantly expanding and evolving. Developers are always on the lookout for quality 2-D and 3-D artists to create new character designs, and then turn them into walking, talking action heroes.

The initial work for a 2-D cartoonist (someone who works with traditional materials, not a computer) in computer-game design is very similar to that of the character designer in traditional animation. Both need to draw a variety of poses for each character in the game or cartoon. The difference comes when the computer-games designer has to take into consideration the type of character being created in relation to the game's mechanics.

The 3-D artist will take the designs and create a three-dimensional "sketch" on a computer, using a modeling program such as Poser. This will give the programmers a better idea of how the character will look and move.

The type of graphics that are used will also have to be taken into consideration. Sprites are images created from thousands of small dots or squares (each one known as a sprite). These are used in games on the GameBoy hand-held player. More commonly, polygons are used. These are much larger areas that intersect to create a 3-D figure, and are seen on games on PCs and consoles like Playstation and Nintendo 64. The most important aspect that the 3-D artist needs to decide on is the pay-off against a complex, detailed design that looks pretty but is sluggish to move in gameplay; or a simpler design that is more fluid in movement and uses less computer memory.

◄ Multi-tasking hero

The design for Crash Bandicoot required the character to jump, run, swim, spin at high speed, and perform many other moves. As the designer, you would have to come up with a range of looks and moves. This is known as building up a posture repertoire.

Character designs for computer games need to be not only **visually appealing** but **functional** as well.

► The original "virtual babe"

One of the most famous computer characters ever created (after Sonic the Hedgehog and Mario) has to be Lara Croft from the Tomb Raider series of games.

SEE ALSO

3-D Modeling **120**

Animation Character Design **142**

WORKING FROM 2-D TO 3-D

1. When creating simple 3-D characters using Poser software, you first need to create the basic figure by choosing the pose, and then decide where to light it.

2. Next, take your 2-D drawings and textures and wrap them around the 3-D figure. This creates the final figure.

3. Finally, add the background, and your character and setting will be complete. This could be used as a simple concept drawing or even as packaging art for the final game.

Over to you...

- Look at a variety of computer games and observe how the characters move. Notice where polygons break down; you can see through the character's body. You'll get a good idea of how the figure's shape was composed.

- Practice creating basic figures in Poser software.

- Design three characters (hero/heroine, villain, and sidekick) for a platform game entitled "Big Bear and Little Cub's Biggest Bouncing Quest Ever!" aimed at the 11-15-year-old market.

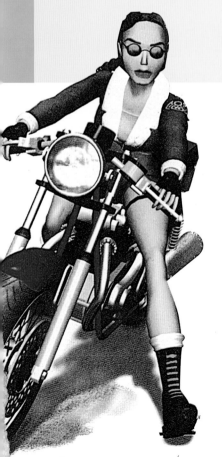

A character will have to be **physically** able to do the **moves** required by the player.

◄ From sketch to screen

The larger picture is a concept drawing for the hero; the inset shows how the hero finally appeared on the screen in the game. Note how the final version is simplified to allow for the smooth movement of the character.

Self-publishing

If, despite your best efforts, you cannot get published by the major comic-book publishers, magazines, or newspapers, what avenues are left? One answer is to become a publisher yourself.

Although this sounds like a daunting task that will cost thousands of dollars, it needn't be difficult or costly. With the advent of accessible photocopying and the vast numbers of cheap printers, it is now possible to produce a series of comics and cartoons for as little as $30.

The first thing you need to do is decide on the format of the comic. You may opt for a small, 8¼ x 5¾ in. (210 x 148 mm) black-and-white photocopied comic of a few pages or, if you have the money, a full-color covered graphic novel of several hundred pages. Think about the shape of the comic—this will be determined by what you are drawing; for example, a collection of

newspaper strips could be presented as a long oblong, whereas a traditional comic book may be better suited to an 11½ x 8¼ in. (297 x 210 mm) format.

The final stage is the most important: distribution. You can give your publications away, sell them to friends and family, or even approach comic- and bookshops—many stock small or self-published work on a sale-or-return basis. It may take time, but the reward is knowing that your work is out there, being seen and sold. There are many groups that assist the first-time small-press publisher, and some of them can be found in Cartoon Connections (pages 154–155).

MAKING A MINI-COMIC

1. A quick and simple way to create a mini-comic is to take a 11½ x 8¼ in. (297 x 210 mm) sheet and fold it in half three times until you have made a small booklet of 16 pages.

2. Pencil each page with a number, note the top and bottom, then unfold.

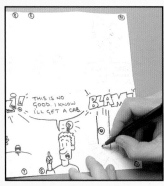

3. Now draw your cartoons on the pages and double-side photocopy the sheet.

4. Take the copy and fold it like the original, staple the middle, and then cut the tops so that all the pages open out. And there you have a mini-comic!

SEE ALSO

 The Workspace 16

 Paper Types 84

 Cartoon Connections 154

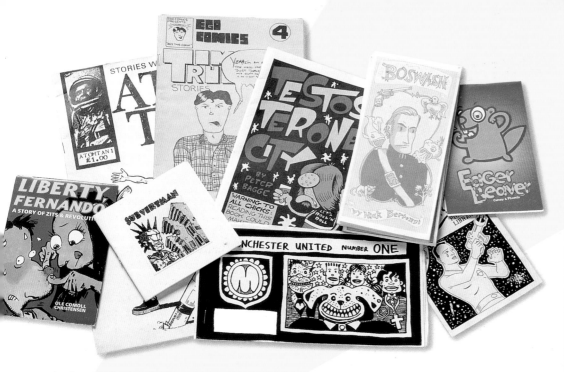

▲ Pick and choose

Self-published comics come in a variety of shapes, sizes, and colors to fit whatever budget you have.

Over to you...

- Plan the right format to suit your artwork and budget.

- If working on a very small budget, try and get access to cheap or free use of a photocopier.

- Remember, some of the world's greatest cartoonists and comic artists started out this way, and it is a great way of exhibiting your work, just like a mini-portfolio.

The **power of self-publishing** is that you have **total control,** from the **creation,** through **editorial** **and printing,** right up to **distribution.**

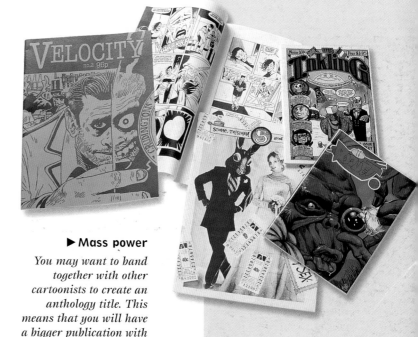

▶ Mass power

You may want to band together with other cartoonists to create an anthology title. This means that you will have a bigger publication with a wider range of content, and you can share the costs of production.

Reprographics

You should be aware of how your work is being handled by the repro house and the printer if you wish to have it look as close to your original artwork as possible. A basic knowledge of reprographics may help you avoid being shocked when you look at your printed work, and will endear you to publishers as someone who knows how things should be.

There are two major color models in use today—RGB (or red-green-blue) or CMYK (or cyan-magenta-yellow-black). The way these models differ is based on color theory: There are three primary colors, and the way these colors mix creates most of the visible spectrum. In the RGB model, the colors are additive: if you add the three primaries, you get white. Likewise, the absence of all three primaries creates black. This is the model that is used in computer monitors and in television. In the CMYK model, which is a subtractive model and used for printing on paper, the three primaries mixed together create black. This is because CMYK is the reflective equivalent of RGB and is used to describe the four process colors used in printing. (When white light hits cyan, the ink absorbs all the other colors, reflecting back cyan.)

Because CMYK is reflective, the number of colors that can be printed is nowhere near the number of colors we can see. This is the reason that you should color your cartoons in CMYK mode on a computer. If you do color in RGB, be prepared for colors to darken and even change when printed.

When we look at photographs, our eyes see the different colors or shades of gray as a continuous tone, that is, with no breaks in the graduations of tones and hues. Unfortunately, no printing press—or desktop printer, for that matter—can replicate this, and not just for the reasons previously stated. When color is printed, it is done so as one solid color at a time because printing ink is sticky and only partially transparent. You can print cyan, magenta, yellow, and black, but you can't

reproduce the subtle colors and grays and the shifts between them. Bearing all this in mind, how do we print color or graduated tones? The answer is the humble halftone. Back in the late nineteenth century, lithographers figured out that you could create a tint of a color by breaking the color down into a series of dots. The smaller and farther apart the dots are, the lighter the color.

sRGB & CMYK

■ sRGB Profile
■ CMYK Profile

In this comparison of the RGB and CMYK gamuts, we can see the small number of colors available for print work.

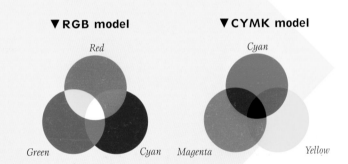

▼ RGB model

Red

Green · Cyan

▼ CYMK model

Cyan

Magenta · Yellow

The model on the left is used in computer monitors and for television, and therefore ideal for use on web sites.

The model on the right is used for print on paper, and ideal for books, magazines, posters etc. Although here it only shows three of the process colors, the fourth, K (the Key color ie. black) is an extra color added during the printing process. A full-color image is made by laying down the four process colors in sequence as the paper runs through the press. We get past the inherent problems of laying down ink over ink by breaking the image into a halftone, or series of dots. So what we have with a color image is four separate halftones, one each for the four process colors.

SEE ALSO

Tone and Color Principles 100

Scanning 114

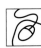
Image Editing 122

DOTS

You should always take into account the final screen frequency that your work will be printed from, and scan in your originals to match with a resolution that's no bigger than one and a half the output screen frequency. This means that if you're using a halftone screen of, say, 150 lpi (lines per inch), you shouldn't scan at a resolution of more than 300 dpi (dots per inch). The resolution of a scan should be 1.5 times the screen frequency or, more simply,
dpi = lpi x 1.5.

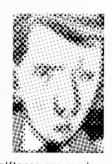

Halftones are made up of spots that sit in a big grid. Often there are too many spots to count, so we count how many rows of spots per inch there are in that grid. This is called the frequency of the halftone, and it's measured in lines (the technical term for rows) per inch, or lpi.

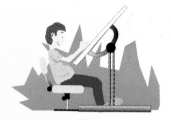

85 lpi

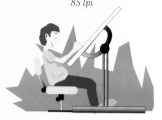

175 lpi

The lower the screen frequency, the coarser the screen—the spots will be bigger and the image will be rougher-looking. The dots that make up the image will be more visible. Overall, the eye will not be fooled into thinking that the image has a continuous tone.

Over to you...

- Check the phone book for printers and repro houses near you. Contact them with questions and arrange a visit. Most will be pleased to oblige.

- Go to your library and take out books on printing (we've listed some in the bibliography; see pages 154-155).

- Search the web for resources on reprographics. There's a wealth of information out there!

▼ **Checking proofs**

In proofing, the repro house runs out a special print of your work, called a proof, for you to check for mistakes. Proofs come in a variety of forms, from inkjet printouts to an expensive photographic process like Matchprint or Chromalin. Always ask for proofs, and check them thoroughly. This is the last chance to make any corrections to your work.

Knowing at least some of **the basics** of reprographics will **help you create better looking work** when printed and will **keep surprises to a minimum.**

World Wide Web Publishing

More and more cartoonists are discovering the Internet as a potential new venue for showcasing and publishing their work. By posting their comics and cartoons on the web, they can reach a potential audience of millions of people.

Although posting your comics on the World Wide Web is becoming easier, there are a few things to consider. First, the web is not print-obvious, but by allowing for this, you can give your readers a better reading experience. In print, the normal layout for pages is portrait (i.e., the smaller sides are at the top and bottom), whereas most monitors are landscape (the smaller sides are on the left and right). Second, don't be afraid of color. The color gamut is much wider in RGB (red, green, and blue, the color model that monitors use) than the print gamut of CMYK (cyan, magenta, yellow, and black, the inks used in four-color printing). This means that the colors will be brighter and more saturated on screen than in print, and that color is no more expensive than black and white, as is the case with printed materials. Third, use the hypertextual capabilities of the Internet to create a new way of showing your cartoons—you can even use animation, sound, and interactivity to enhance your talent!

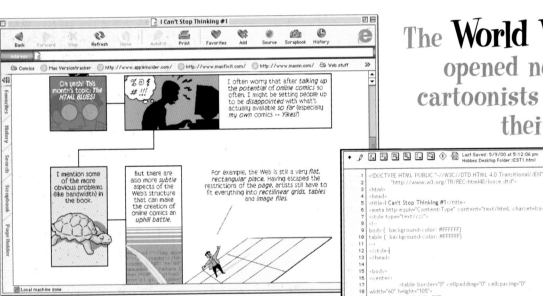

▲ Screen size

The standard screen sizes in use today are 640 x 480px (pixels), 800 x 600px, and 1024 x 768px. It's up to you which of these screen sizes you use, but don't forget that not everybody has the latest equipment—designing on a large scale may mean that others have to scroll around the pages to see everything.

The **World Wide Web** has opened new doors for cartoonists to **showcase** their work.

◀ Coding by hand

You're going to need a basic knowledge of HTML (Hypertext Markup Language) to create your pages. There are plenty of good books on the subject, and as computer languages go, it's fairly easy to master. Most cartoonists who use the web use HTML to set up the framework and then drop in the illustrations.

SEE ALSO

 Tone and Color Principles **100**

 Drawing with a Mouse or Graphics Tablet **112**

 Storing Digital Files **124**

► Images for the web

When drawing for web pages, you can scan in drawings and touch them up in a paint program, or create the whole thing from scratch in the paint program itself. The most important factor is how long the page will take to load in the reader's browser—if it is too large, most people won't bother.

Preview of image format *Setting for output*

Transparency controls *Preview of different image format* *Settings for preview planes*

Over to you...

- If you have access to the Internet, use a search engine to look for online cartoons and comics. Use your browser's Source function to see how the page is made up.

- Check out the free Internet providers—many offer free web space. This is perfect for cartoonists who want to start putting their work online.

- Look up http://www.scottmccloud.com for lots of information on online comics from a man who truly believes that digital delivery of cartoons is the way forward.

- Experiment with the compression settings for GIF and JPEG. At what point does the balance between having a small file size and a decent image tip over to making the image unusable?

- To keep web page sizes down, always create your images at 72 dpi (dots per inch). (Most monitors cannot show more than this anyway.)

◄ GIF images

Remember to use the right file format for your images. The most common formats are GIF and JPEG. In general, GIFs should only be used for images that have mostly flat colors, because these will compress very well (and you can only use a maximum of 256 colors anyway). If you want transparent areas in your images (i.e., where the background shows through), then GIF is the format to use.

◄ JPEG images

Images that are more like photographs, because they have a wide range of tonal values, should be saved as JPEGs. These show a larger number of colors and are excellent with tonal values, but every time you save a JPEG, you lose a little more picture information, so only save images after you have finished working with them.

Glossary

Acetates
Sheets of transparent film used as overlays on artwork.

Airbrush
A mechanical painting tool producing a fine spray of paint or ink, used in illustration, design, and retouching.

Artboard
Heavyweight paper used for drawing and painting. Bristol board is the best known type of artboard.

Art(work)
Any illustrative matter prepared for reproduction, such as illustrations. Usually distinct from the text.

Bézier curve
In object-oriented drawing applications, a mathematically defined curve between two points (Bézier points).

Binding
The method by which a book or magazine is bound together. The two main types are saddle-stitching or stapling, and perfect-bound (where the pages are glued into the spine).

Bitmap
A text character or graphic image comprised of dots or pixels (picture elements) in a grid. Together, these pixels—which can be black, white, or colored— make up the image.

Bleed
The part of an image that extends beyond the trim of a page.

Blue pencil
A type of pencil that needs no erasing, as the blue color of the lead doesn't show up when reproduced.

CD-Rom
Stands for Compact Disk Read only memory. A non-erasable storage system of large capacity.

CMYK
Cyan, magenta, yellow, and black—the inks used in four-color printing.

Color correction
An adjustment of the color values of an illustration that is done by adjusting the color scanner to produce the correct result.

Copyright
The right of the creator of an original work to control the use of that work. Ownership of copyright does not necessarily mean ownership of the work itself, nor does it necessarily cover rights to that work throughout the world.

Crop marks
Short lines printed onto pre-cut printed sheets to show where to trim the paper for folding and binding.

Cross-hatching
Drawn lines that intersect to create graduations of tone and form.

Dots per inch (dpi)
The unit of measurement that represents the resolution of a device such as a printer, imagesetter, or monitor. The higher the dpi, the better the quality.

EPS
Stands for Encapsulate PostScript. A computer image format that is composed of vectors— mathematical expressions that allow an image to be scaled to any size without any loss of image quality.

Feathering
Marks made with a brush to signify form and tone. Also refers to the spreading of ink on rough paper.

File compression
The condensing of data within a file so that it occupies less space on a disk and is quicker to transmit over telecommunication lines.

Font
Another name for a typeface. Used primarily in connection with computers.

Full script
A method of writing a story for comics that shows the artist exactly what happens in each panel.

GIF
Stands for Graphic Interchange Format—a computer image format used on the World Wide

Web for images with less than 256 colors. Good for bold graphics.

Graphics tablet
An input device that allows you to draw or write using a pen-like instrument as if you're working on paper.

gsm
Grams per square meter—a unit of measurement indicating the substance of paper on the basis of its weight, regardless of the sheet size.

HTML
Stands for Hypertext Markup Language—programming language for creating websites.

Imposition
The method by which a printer arranges the pages of a book so that they will appear in the correct order with the appropriate margins after binding.

Inking
Tracing over the rough pencil lines of a cartoon with ink ready for publication.

JPEG
Stands for Joint Photographic Experts Group—a computer image format used for images with lots of colors or with a continuous tone.

Lettering
The drawing of letters to create text such as dialogue and captions.

Lightbox
A glass-topped box with a powerful light source. Used by cartoonists to trace artwork and inking.

Penciling
The step of roughing out a cartoon or comic to ensure the correct placement of drawings such as figures and backgrounds.

Photostat
A photographic image made by a photostat machine.

PostScript
A computer language that is used by 95 percent of the world's imaging and printing systems to recreate images and page layouts.

Raster
The method of display used on monitors, whereby the screen image is made up of a pattern of several hundred parallel lines created by an electron beam of varying intensity raking the screen at successive points at a very high speed.

Register
Positioning one piece of art over another to ensure the correct relationship between the two.

RGB
Red, green, blue—additive colors.

Scanner
An electronic device that converts artwork and transparencies into digital form so that they can be manipulated by a computer.

Squaring up
Ruling out the page borders ready for creating an artwork.

Swipe
A piece of art that one cartoonist has copied from another and used in their own work.

TIFF
Stands for Tagged Image File Format—a computer image format used by most page layout and imaging programs for pictures; the files are easily compressed.

Thumbnails
Small rough layouts of cartoons used by some artists as a guide for the actual artwork.

Vector
A computer image made up of curves as created by drawing programs that use the PostScript language.

Wash
A method of creating tonal values in an image using watered down ink to create gray tones.

Zipatone
The generic term given to the pastedown dot and line pattern sheets used to create tones. Also called Letratone and Benday patterns.

Cartoon Connections

GENERAL WORKS ON CARTOONING

Baetens, Jan, and Lefèvre, Pascal *Pour Une Lecture Moderne de la Bande Dessinée* Centre Belge de la Bande Dessinée, 1993.

Barker, Keith, ed. *Graphic Account* Library Association Youth Libraries Group, 1993.

Bongco, Mila *Reading Comics: Language, Culture, and the Concept of the Superhero in Comic Books* Garland Studies in American Popular History and Culture, Garland, 2000.

Bryant, Mark & Heneage, Simon *Dictionary of British Cartoonists and Caricaturists* Scholar Press, 1994.

Carrier, David *The Aesthetics of Comics* Pennsylvania State University Press, 2000.

Clarke, Phil and Higgs, Mike *Nostalgia About Comics* Assisted by Sue Williams. Pegasus, 1991.

Dierick, Charles and Lefèvre, Pascal, eds. *Forging a New Medium: The Comic Strip in the Nineteenth Century* VUB University Press, 1998.

Douglas, Allen, and Malti-Douglas, Fedwa *Arab Comic Strips: Politics of an Emerging Mass Culture* Indiana University Press, 1994.

Eisner, Will *Graphic Storytelling* Poorhouse Press, 1996.

Gaumer, Patrick, and Claude Moliterni, eds. *Dictionaire Mondial de la Bande Dessinée* Larousse, 1994.

Goulart, Ron *Comic Book Culture: An Illustrated History* Collectors Press, 2000.

Groensteen, Thierry *Système de la Bande Dessinée Formes Sémiotiques* Presses Universitaires de France, 1999.

Horn, Maurice, ed. *The World Encyclopedia of Comics* Chelsea House, 1998.

Horn, Robert E. *Visual Language: Global Communication for the 21st Century* MacroVU, 1998.

Kunzle, David *The History of the Comic Strip: The Nineteenth Century* University Press of California, 1990.

Lent, John A. *Comic Art in Africa, Asia, Australia, and Latin America: A Comprehensive, International Bibliography* Greenwood Press, 1996.

Lent, John A. *Comic Art of Europe: An International, Comprehensive Bibliography* Greenwood Press, 1994.

McCloud, Scott *Reinventing Comics* Paradox Press-DC Comics, 2000.

McCloud, Scott *Understanding Comics: The Invisible Art* Kitchen Sink Press, 1993.

Moliterni, Claude, Philippe Mellot, and Michel Denni *Les aventures de la BD* Gallimard 1996.

Morgan, Harry & Manuel Hirtz *Le Petit Critique Illustré* PLG, 1997.

Naepel, Oliver *Auschwitz im Comic—Die Abbildung unvorstellbarer Zeitgeschichte* [Auschwitz in Comics—The Depiction of Unimaginable Contemporary History] Muenster: LIT, 1998.

Rothschild, D. Aviva *Graphic Novels: A Bibliographic Guide to Full-Length Comics* Libraries Unlimited, 1995.

Sabin, Roger *Adult Comics: An Introduction* Routledge, 1993.

Sabin, Roger *Comics, Comix, & Graphic Novels: A History of Comic Art* Phaidon, 1996.

Scott, Randall W. *The Comic Art Collection Catalog: An Author, Artist, Title, and Subject Catalog of the Comic Art Collection* Special Collections Division, Michigan State University, Greenwood Press.

BOOKS ON CREATING CARTOONS

Barto, Renzo *How To Draw Cartoon Characters* Watermill Press, 1994.

Barnhart, Duane & Angie *Duane Barnhart's Cartooning Basics: Creating the Characters* Cartoon Connections Press, 1997.

Duc *L'Art de la Bande Dessinée* Ed. Glénat, 1996.

Eisner, Will *Graphic Storytelling* Poorhouse Press, 1996.

Gautier, Dick *Drawing And Cartooning 1,001 Figures In Action* Perigee, 1994.

Glasbergen, Randy *How to be a Successful Cartoonist* North Light Books, 1995.

Haines, Lurene *A Writer's Guide to the Business of Comics* Stabur Press, 1995.

Hamm, Jack *Drawing & Cartooning For Laughs* Perigee, 1990.

Hart, Christopher *Cartooning for the Beginner* Watson-Guptill Publications, 2000.

McKenzie, Alan *How to Draw and Sell…Comic Strips* Titan Books, 1998.

Mercadoocasio, Gwenn *How To Draw Comics* Longmeadow, 1994.

Muse, Ken *The Total Cartoonist* Prentice-Hall, 1985

Nordling, Lee *Your Career in the Comics* Andrews McMeel, 1995.

Schulz, Charles M. *Funny Pictures: Cartooning With Charles M. Schulz* HarperCollins, 1996.

Tallarico, Tony *Drawing And Cartooning Monsters: A Step-By-Step Guide For The Aspiring Monster-Maker* Perigee, 1992.

Whitaker, Steve *The Encyclopedia of Cartooning Techniques* Headline Book Publishing, 1996.

CARTOON ORGANIZATIONS

Anonima Fumetti—Italian
Cartoonists Society
via Botero 17
10121 Torino, Italy
Tel: (39) 011 5170147
Fax:(39) 011 5170147
E-mail: anonima@fumetti.org *or*
anonimafumetti@tin.it

The Association of American
Editorial Cartoonists (AAEC)
4101 Lake Boone Trail
Suite 201
Raleigh NC 27607
U.S.A.
Tel: (919) 787-5181
www.detnews.com/AAEC/
AAEC.html

Australian Cartoonists Group
P.O. Box 39
Plympton
Southern Australia
www.mfrworks.com.au/acg/

The Cartoon Art Trust
7 Brunswick Centre
London
WC1N 1AF, U.K.
E-mail: skp@escape.u-net.co.uk

Graphic Artists Guild
90 John Street
Suite 403
New York NY 10038
U.S.A.
Tel: (800) 500-2672
Fax: (212) 791-0333
www.gag.org/index.html

CARTOONING WEB SITES

www.cartooncorner.com

www.cartoonet.com

www.cartoon-links.com

www.cartoonsforum.com

www.cartoonstock.com

cagle.slate.msn.com/hogan

www.execpc.com/ ~ mooncraz/
almanac.html

www.georgetown.edu/spielmann/
icaf.html

www.inkspot.com

www.lib.msu.edu/comics

library.ukc.ac.uk/cartoons

members.aol.com/chrisbrow/
comic.html

www.scottmccloud.com

www.sentex.net/ ~ sardine/
tool.talk.html

www.spirit.com.au/ ~ pat/

www.teleport.com/ ~ ennead/
ampersand/how_to.html

www.ucc.uconn.edu/ ~ epk93002/
comix.html

www.unitedmedia.com/comics/
dilbert/scott/index.html

www.unitedmedia.com/ncs/ncs.html

www.telemagination.co.uk

www.sentex.net/ ~ sardine/
spfaq.html

Index

Credits

Quarto and the authors have made every effort to contact and duly credit all authors, artists, and original copyright holders of materal appearing in this book. We apologize in advance for any omissions or errors, and would be grateful to receive notification of such so that we may correct this information in future editions.

(Key: l left, r right, t top, c center, b bottom)

page 1 © Roger Langridge; page 2 © Colin Mier; page 8 Bill Watterson, Calvin & Hobbes © UFS; page 9t © Steve Bell; page 9b Charles Schulz, Peanuts © UFS; page 12 © Tim Pilcher; page 15 Ferlut, Fournier, Nicolas & Cesano, from Le Petit Theatre de la Bande Dessinée, © The Authors; page 16 © Brad Brooks; page 22tr Apple Computer UK; page 22bl Compaq; page 24 Duc L'Art de la BD © Glénat; p125tr Compaq; page 25tl © Herge; page 25b Johan de Moor, A Mort L'Homme Vive L'Ozone, © Editions Casterman; pages 26/27 © Roger Langridge 2000; page 28t © Roger Langridge; page 28bl Eduardo Risso/DC Comics, 100 Bullets, © 1999; page 28bc Mike Parobeck and Rick Burchett/DC Comics, Batman Dark Knight Adventures ©1993; page 28br Francois Boucq/Catlan Communications, Billy Budd ©1991; page 29t Duc L'art de la BD © Glénat; page 29b © Roger Langridge; page 30 © Roger Langridge; page 31t Jamie Hewlitt and Alan Martin, Tank Girl © 1995; page 31b © Roger Langridge; page 32t Steve Whitaker, Whitto ©1991; page 32lc Roger Langridge/Peter Bagge, Girly Girl © 1999; page 32bc Martin Hand, Hulk, © Marvel Comics; page 33t © Ted McKeever; page 33cr Pegotte, Spirou ©1992; page 33cl Will Elder ©1979; page 33b © Preston Blair Cartoon Animation; page 34l © Roger Langridge; page 34lc Graham Higgins, Fear © 1988; pages 34rc/35lc/35br Julio Martinez Perez © Daspastoras; page 34br/35bl Mike Parobeck & Rick Burchett/DC Comics © 1993; page 35tr Steve Yeowell, Zenith © 1988; page 35c © Matt Brooker; page 36l Roger Langridge © 2000; page 36c Brian Bolland © 1988; page 36r Terry Wiley © 1988; page 37t © Roger Langridge; page 37bl Brian Bolland © 1988; page 37br Bercovici/Dupuis © 1992; page 38tl Rian Hughes © 1990; page 38tr Graham Higgins © 1988; page 38bl Kyle Baker, Why I Hate Saturn © 1999; page 38bc Darrick Robertson/Rodney Ramos/DC Comics © 2000; page 38br Duncan Fegredo © Marvel 2000; page 39tl Jonathan Edwards © Aunt Connie and Plague of Beards; page 39tc Miguelanxo © Prado; page 39tr Malik/Dupuis © 1992; page 39bl/39bc © Serge Clerc; page 39br Bercovici/Dupuis ©1992; page 40tl AnHerge/Editions, The Castafiore Emerald Casterman © 1963; page 40tc Eduardo Risso/DC Comics, 100 Bullets Francois © 1999; page 40tr Franquin/Editions Dupuis, Gaston © 1968; page 40bl

Boucq/Catalan Communications, Billy Budd © 1991; page 40c Andrew Brandou, Howdy Partner © 1999; page 40br De Carlo/DC Comics © 1973; page 41 © Tim Pilcher 2000; page 42bl Rob Davies, Football © 1992; page 42c Bercovici/Dupuis, Nurse © 1992; page 42t/page 42rc/page 43bl Tome and Janry, Le Petiut Spirou, © Dupuis 1994; page 43tl/page 43tc Tim Pilcher © 2000; page 43tr Dave Gibbons, Sikh © 1988; page 44bc Serge Clerc © 1982; page 43br Hunt Emerson, Ryme of the Ancient Mariner ©1989; page 44t Hanna Barberra, Yogi Bear © 1963; page 44b Tim Pilcher © 2000; page 45t/page 45br Johan de Moor, La Vache © Editions Casterman; page 45lc Toto L'Ornithorynque et les Predatueurs, © 1999 Guy Delcourt Productions; page 45bl La Queue du Marsuplami Franquin © Mardu Production 1987; page 45 © Thelwell; page 46 © B. Brooks; page 47t A Contract with God © Will Eisner; page 47lc Alberto Breccia, Mort Cinder © Breccia Glénat; page 47rc Alex Toth, Bravo for Adventure © Alex Toth; page 47b André Franquin, Idées Noires © Franquin; page 48bl Katsuhiro Otomo, Akira © Kodansha and Otomo; page 48br © Vaughn Shoemaker; page 49t Bernard Krigstein, Master Race, © 1960 E.C. Productions; page 49bl Jack Kirby, The Fantastic Four © Marvel Productions; page 49c Bill Watterson, Calvin & Hobbes © UFS; page 50b/51b © Brad Brooks; page 51t René Goscinny/Albert Uderzo, Astérix © Editions Albert Réne; page 54 Alberto Breccia, Mort Cinder © Breccia; page 55t Will Eisner, The Spirit © Will Eisner; page 55b Alan Moore/Dave Gibbons, Watchmen © DC Comics; page 55 © Brad Brooks; page 58bl John Prentice from Rip Kirby © KFS; page 58tr Lacroix/ Genin from Yann Le Migrateur © Glénat; page 59t Paul Gillon from Les Naufrages du Temps © Humanoides Associes; page 59c Réne Goscinny/Albert Uderzo from Asterix © Albert Rene; page 59br John Higgins, World without End © John Higgins & Jamie Delano; page 60bl Tito & Varalli from Soledad © Ed. Casterman; page 50tr Greg & Hermann, from Bernard Prince © Ed. Du Lombard; page 61t Caza, from Scenes de la vie de banlieue © Ed. Dargaud; page 61br Briggs, When the Wind Blows © Raymond Briggs; page 62 Dureaux from Pierrot Le Fou © Glénat; page 63lc Peyo, from Johan et Pirlouit © Ed. Dupuis; page 63t Tome & Janry, Spirou and Fantasio © Dupuis; page 63br/65br Breccia from Mort Cinder © Glénat; page 64 Burne Hogarth from Tarzan © ERB, UFS; page 64bc/65t Réne Goscinny & Albert Uderzo from Asterix © Ed. Albert Réne; page 64tr Hugo Pratt from Corto Maltese © Casterman; page 66l Marc-Antoine Mathieu © Delcourt; page 66r Jaime Hernandez from Love & Rockets © J.Hernandez & Fantagraphics; page 67l Breccia from Mort Cinder © Glénat; page 67t Hugo Pratt from Ernie Pike © Glénat; Bart Sears, The Violator © Image Comics 1998; page 68l David Chelsea, from Perspective for Comic Book Artists © David Chelsea;

page 68r © Brad Brooks; page 69b Paul Gillon, from *Jérémie* © Vailliant; page 69t © Brad Brooks; page 70l © Brad Brooks; page 70r Winsor McCay, from *Little Nemo in Slumberland* © Winsor McCay; page 71t from *Chomage* © Humanoides Associes; page 71b Walt Kelly, from *Pogo* © Walt Kelly; page 72 Ty Templeton, from *Little Known Facts About the World of Cartooning* © 1994; page 73 © David Low; page 74l Tim Pilcher © 2000; page 74r Gary Leach, *Sketches from Warrior* © 1984; page 75 Simon Gane, Sap 2 © 1997; page 76/77b © Tim Pilcher; page 77t Rick Pincherra, Crust, Top Shelf Comics © 1997; pages 78/79 Tim Pilcher, The Buccaneer Trading Co. © 1998; page 81 © Tim Pilcher; page 82/83 © Brad Brooks; page 87/90/91 © Brad Brooks; page 92 Moebius, from *La Deviation* © Jean Giraud; page 93 Drew Friedman © Drew Friedman; page 95b Charles Burns, from *Black Hole* © Charles Burns; page 95t © Mort Gerberg; page 96l © Graham Rawles; page 95r © Carl Flint; page 97l Paul Johnson Rites of Alchemy © 1996; page 97c Paul Johnson & Tim Pilcher, Tim True Stories © 1994; page 97b Paul Johnson, Rites of Alchemy © 1996; page 99 Marvelman/Miracleman Alan Moore/Garry Leach © 1982; page 100tl Goran Sudozuka, Outlaw Nation 1 © 2000; page 100b Moebius, The Airtight Garage © 1995; page 100c Dieter/Plessix, Neekibo © Ed. Delcourt; page 100r Berni Wrightson, Plop © 1973 D.C. Comics; page 101t Daniel Torres © 1995; page 101bc © Ana Miralles; page 101br Brad Brooks & Tim Pilcher, Weird Things © Brooks & Pilcher; page 103 Michel Plessix, Julian Boisvert © Delcourt 1985; page 105t Joost Swarte © 1987; page 105b Lorenzo Mattotti, Fires © 1985; page 106 Derib, from *l`Aventure d`une BD* © Editions du Lombard; page 107t Jonathan Edwards, from *Aunt Connie & the Plague of Beards* © Jonathan Edwards & Les Cartoonistes Dangereux; page 107b Ayroles, Maiorana & Leprovost, Garulfo © Ed. Delcourt; page 109t Charles Adlard, from *White Death* © Les Cartoonistes Dangereux; page 109bl © Brad Brooks; page 109c Rian Hughes, from *Dare* © Fleetway Publications; page 109 Dave McKean, Cages © Dave McKean; page 100 © Matt Petch; page 111 © Rian Hughes; page 121t Scott McCloud, from *The New Aventures of Abraham Lincoln* © Scott McCloud; page 121b Brad Brooks © New Wine Conferences; page 126/128l Slim/DC Comics, Plop © 1973; page 177 Walt Kelly, from *Pogo* © 1974; page 128r Tim Pilcher © 2000; page 129tl Charles Addams © 1954; page 129bl Dan Piraro © 1998; page 129c Ronald Searle © 1946; page 129b Posy Simmonds © 1986; page 130l David Low, Prince Phillip; page 131t Steve Bell, Thatcher`s Departure © 1989; page 131bl Robert Stewart, Sheriffs © 1949; page 131br Pat Oliphant © 1997 Universal Trees Syndicate; page 132 Tim Pilcher © 1998; page 133t Ed Hillyer © 1999; page 133c Lewis Trondheim/Editions du Seuil © 1995; page 133b Frank Cho/Creators Syndicate, Liberty Meadows © 1998; page 134 Steve Bell, Bell's Eye © 1997; page 135t Pat Oliphant, Oliphant's Anthem © 1989; page 135c Signe Wilkison © 1988; page 135b Pat Oliphant, Nine lives and counting © 1993; page 136 Rian Hughes © 1999; page 137 Head & Shoulders © 2000; page 138b © Tim Pilcher 2000; page 138t Philip Ridley © 1989 & Chris Riddell © 1995, Dakota of the White Flats; page 139t Jonathan London & Frank Remkiewicz, Let`s Go, Froggy © 1994; page 139b Nick Sharratt, There`s a Pharaoh in our Bath! © 1995; page 140 Tim Pilcher © 2000; page 141t © Martin Chatterton; page 141b David Lyttleton, Business © 2000; page 142l Preston Blair © 1994; page 142r Batman DC Comics © 1998; page 143t DC Comics, Harley © 1999; page 143b © Preston Blair; page 144 Sony © 2000; page 145t © Greg Carter 2000; page 145bl Eidos/Core Design, Pictures of Lara Croft © 1999; page 145br © Konami; page 149l Jonathan Edwards, Aunt Connie and the Plague of Beards © Jonathan Edwards & Les Cartoonistes Dangereux; page 149r © Brad Brooks; page 150/151t Scott McCloud, I Can't Stop Thinking; page 151b images by Rian Hughes.

All other photographs and illustrations are the copyright of Quarto Publishing.

Quarto would also like to thank Ilya, Jake, Woodrow Phoenix and Zeel at Detonator, for allowing us to photograph them at work.

Author acknowledgements

Tim Pilcher would like to thank the following:
Adele, Megan and Oscar Tyger-Bud, and my parents. Thank you for all you love, patience and support. We got there in the end! Love eternally, TP.

Brad! Brooks would like to thank the following:
Mum & Dad, who encouraged my obsession with cartoons with love; Paul Gravett, Dylan Horrocks, and Gene Kannenberg, who are the true heroes of the form; and most importantly, Elizabeth, my wonderful wife, without whom I'd be nothing and who I love more than anything else in this world. For everyone else: WWJD?

Steve Edgell would like to dedicate this book to James Gilray, the best cartoonist ever.